The Cape Cod National Seashore

A Photographic Adventure and Guide

Christopher Seufert

Schiffer Publishing Ltd®

4880 Lower Valley Road • Atglen, PA 19310

Designed by John P. Cheek
Cover design by Bruce Waters

Type set in GoudyOlSt BT/Parasine Clair

ISBN: 978-0-7643-3995-0
Printed in China

Schiffer Books are available at special discounts for bulk purchases for sales promotions or premiums. Special editions, including personalized covers, corporate imprints, and excerpts can be created in large quantities for special needs. For more information contact the publisher:

Published by Schiffer Publishing Ltd.
4880 Lower Valley Road
Atglen, PA 19310
Phone: (610) 593-1777; Fax: (610) 593-2002
E-mail: Info@schifferbooks.com

For the largest selection of fine reference books on this and related subjects, please visit our website at www.SCHIFFERBOOKS.COM
We are always looking for people to write books on new and related subjects. If you have an idea for a book, please contact us at proposals@schifferbooks.com

This book may be purchased from the publisher.
Please try your bookstore first.
You may write for a free catalog.

In Europe, Schiffer books are distributed by
Bushwood Books
6 Marksbury Ave.
Kew Gardens
Surrey TW9 4JF England
Phone: 44 (0) 20 8392 8585; Fax: 44 (0) 20 8392 9876
E-mail: info@bushwoodbooks.co.uk
Website: www.bushwoodbooks.co.uk

Acknowledgments

I'd like to thank, first and foremost, my wife Lisa for providing the loving support to both shoot and edit this project specifically and for believing in my books in general.

My intern Colleen Cunha provided adventurous company and a welcome gear-hand through the trails and soft sand treks. My gallery business partner, Richard Koury, also brought another welcome point of view to some of my hikes into the swampy unknowns and abandoned houses. Thanks to NPS ranger Bill Burke for the gracious forward and to the entire staff at the National Seashore, and specifically to my old friend Jenna Sammartino, who thought of me for the 50th anniversary photography exhibit at the Salt Pond Visitor Center.

Thanks to my editor Douglas Congdon-Martin in guiding me through this second book with Schiffer Publishing.

And my kids, Alena, Ethan, and Stella do not go forgotten here, providing the joy at the end of every arduous day.

Foreword

Sometimes it takes years to discover the hidden gems in your own backyard. Whether you are a real "native" Cape Codder or a newcomer, photographer Christopher Seufert is guaranteed to open your eyes to the treasures around you in this mystical place called Cape Cod National Seashore. Her 43,000 acres of land and water abound in both "front-country" and "back-country" finds that run the gamut from a shipwreck baking in the sun high on the beach, to the fearsome jaws of a snapping turtle lurking beneath the shallow shores of a pond. As a naturalist and historian for the Seashore for many years, I have to say that Christopher's images capture places and things I have never seen, as well as frame the more familiar things I have seen in a creative way that confirms my belief that you take things for granted in life and overlook beauty and inspiration.

Reaching a robust 50 years old in 2011, the complex and at times controversial Cape Cod National Seashore is by no means fully explored. Seashore scientists go out daily to measure, map, and monitor sea level rise and coastal change, ground water systems, wildlife habitat, estuaries, and salt marshes. Historians and archeologists preserve the fragile pieces of the past. Christopher's book can be seen as a companion piece to their work, and he highlights many of these special resources that our Seashore staff tend to in their daily work. The biggest treat for me was seeing the landscapes that we all live and work in everyday from the air – Christopher's aerials are an awesome revelation of how fragile and small our peninsula really is. Enjoy the book and experience your Seashore like you never have before. And follow up on the inspiration you feel and take along a young child or grandchild out into the subtle grandeur of Cape Cod National Seashore so the next generation will continue the exploration of the place where land meets sea.

William Burke,
Cape Cod National Seashore Historian

Preface

These sands might be the end or the beginning of a world.
—Henry Beston, *The Outermost House*

THE CAPE COD NATIONAL SEASHORE extends from Long Point in Provincetown down to the Southern tip of Chatham's South Beach, where a recently accreted sand bridge (called the Southway) connects to the federally-managed Monomoy Wildlife Refuge.

As a native Cape Codder, one of my first school field trips was to Eastham's Salt Pond Visitor Center where we watched four films, the *Sands of Time*, *Wooden Ships & Iron Men*, and shorts about Henry David Thoreau and Guglielmo Marconi. It was here that my fascination for the National Seashore began.

In 1990 and 1991 my fascination continued when I worked as an archaeological field technician for the National Park Service helping to excavate the Carns site, an Early to Middle Woodland Native American site extending back 2100 years or so. I spent some very, very cold mornings there in January scraping frozen sand in front of incoming waves.

Fast forward to 2008, when I spent two artist-in-residencies shooting photos, video, and recording audio for a film, photography book, and natural environments CD. I was also getting three weeks away from parenting duties, bathing in the ocean, and snoozing on the beach.

Here in 2011 my fascination has only been stoked as I went about the production of this book. Having already shot some of the more well known tourist spots (Nauset Light, Penniman House, Ft. Hill, etc.) I wanted my focus to be more toward those unknown and neglected spots worthy of more notoriety and attention. I plowed my way through the staff at the Salt Pond Visitor Center, asking them where their favorite "out of the way" spots were and geared a weekly shooting schedule around their scribbled maps and obscure directions. Sites such as Bound Brook, Fresh Brook, Bog House, and Pamet come to mind as utter revelations.

What's clear to me is that I'm on a lifelong journey here of adventures throughout the historical, environmental, and recreational acres encapsulated in the National Seashore. Hopefully, there'll be a Volume Two to this volume. As for me, the exploration of the Seashore continues with no end in sight.

When Cape Codder John F. Kennedy signed the bill authorizing the National Seashore's creation in 1961 the goal, he wrote, was "to preserve the natural and historic values of a portion of Cape Cod for the inspiration and enjoyment of people all over the United States." This was the first time the federal government had created a national park out of land that was primarily in private hands. Months of hearings and meetings were required to produce a bill that balanced private and public interests. Today the Seashore encompasses more than 43,000 acres and draws more than 4,000,000 visitors a year. You should be one of them; say "hi" if you see me on the ground shooting a box turtle or waiting in poison ivy at 10 PM for a coyote.

—Christopher Seufert, Chatham

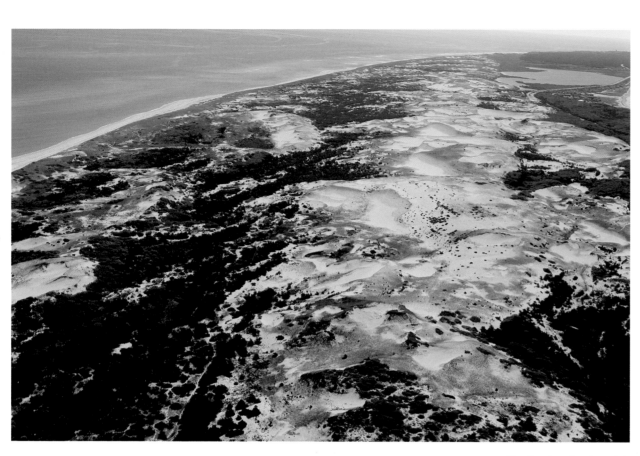

The Provincelands aerial

Ballston Beach dune, Truro

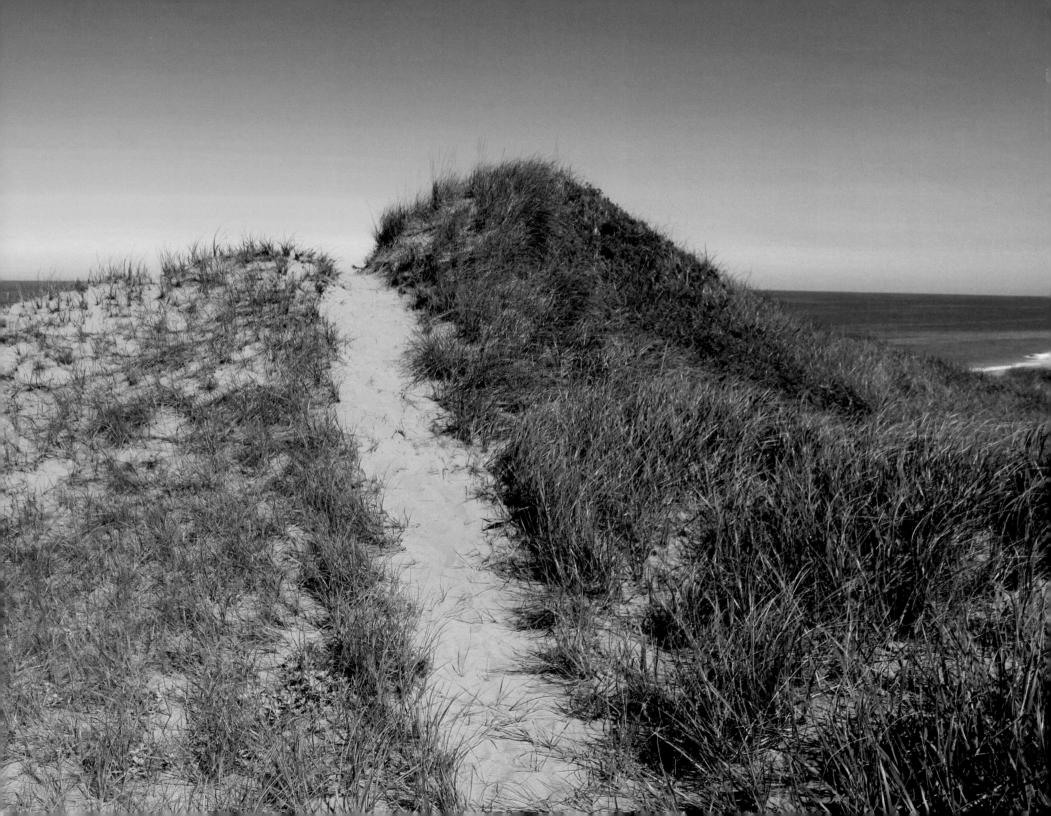

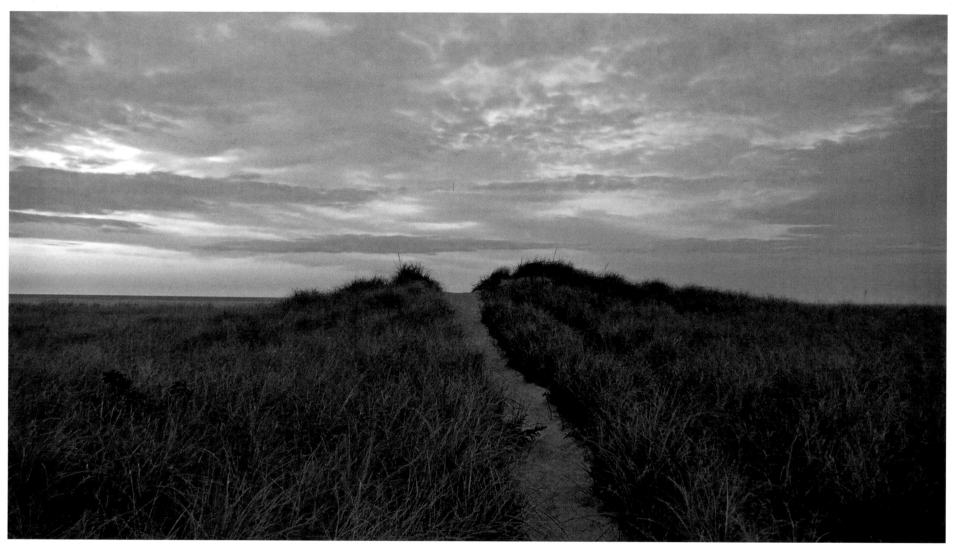

Provincelands daybreak

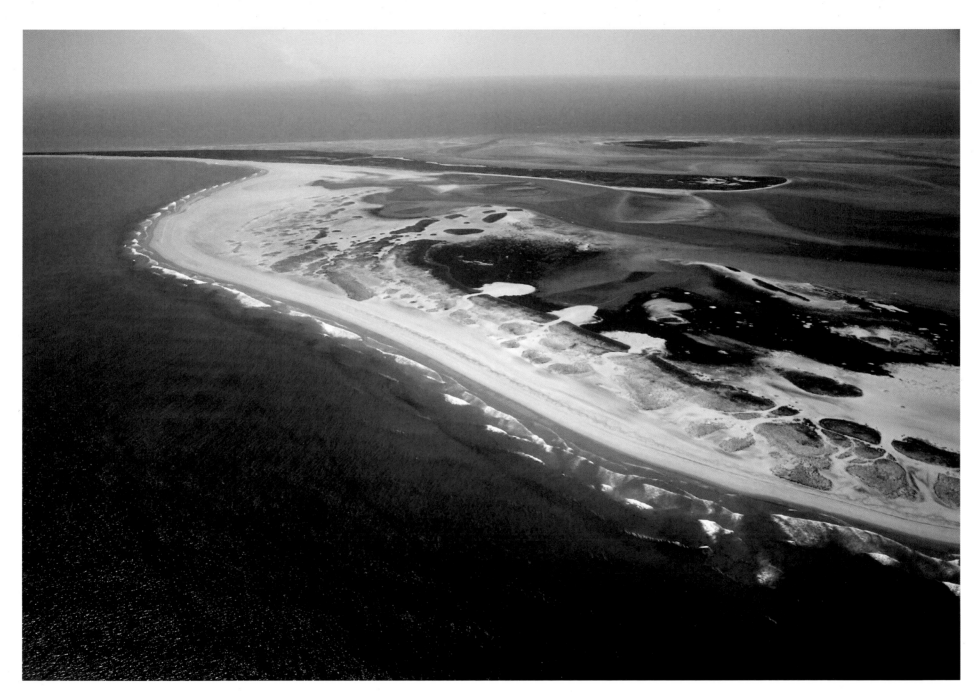

The South Way, Chatham (southernmost point in the National Seashore)

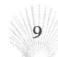

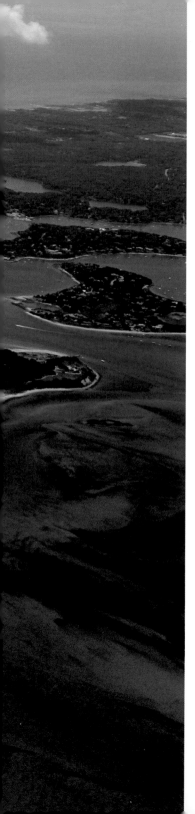

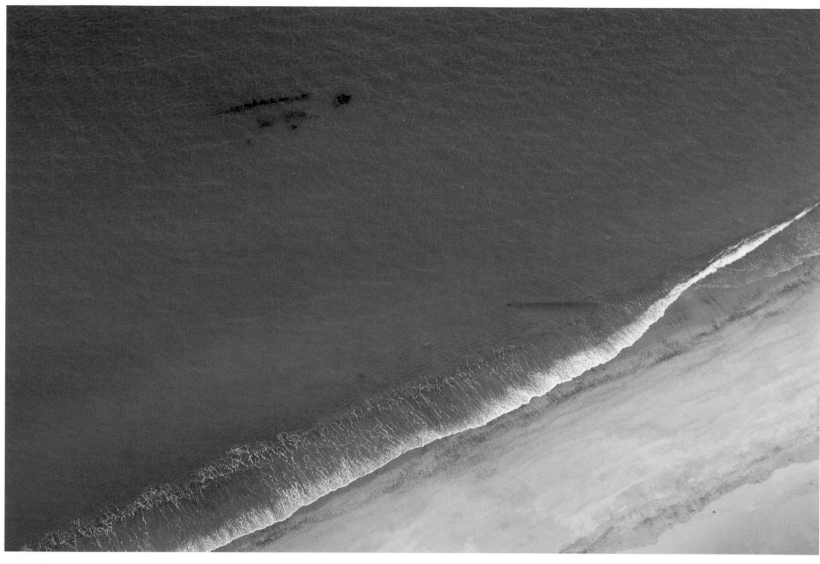

Unknown shipwreck on South Beach (winter 2011), Chatham

Pleasant Bay and the Outer Beach at Chatham

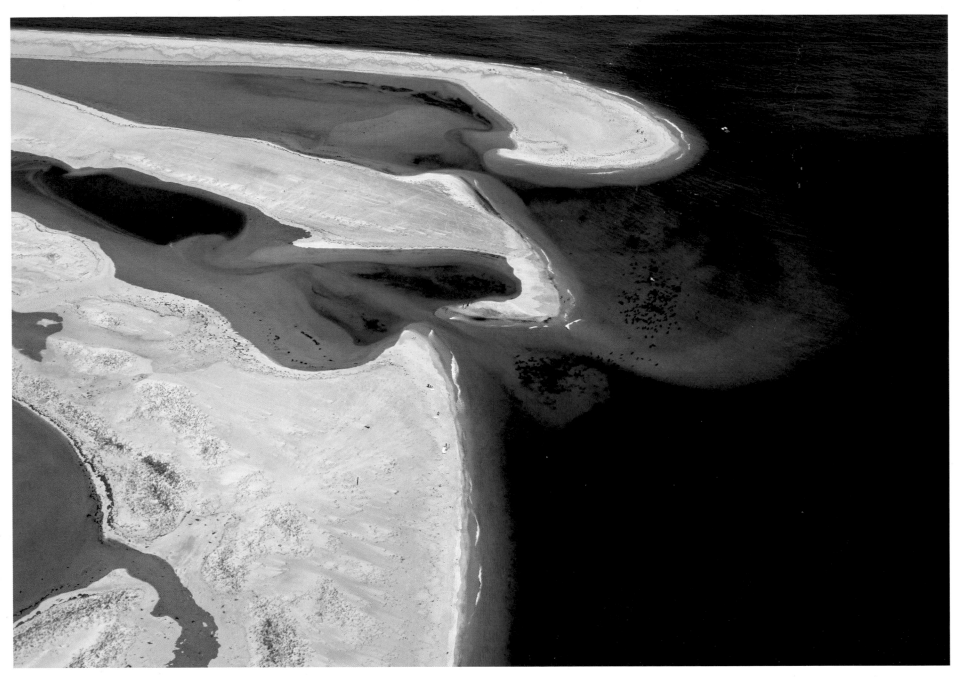

South Island, Chatham

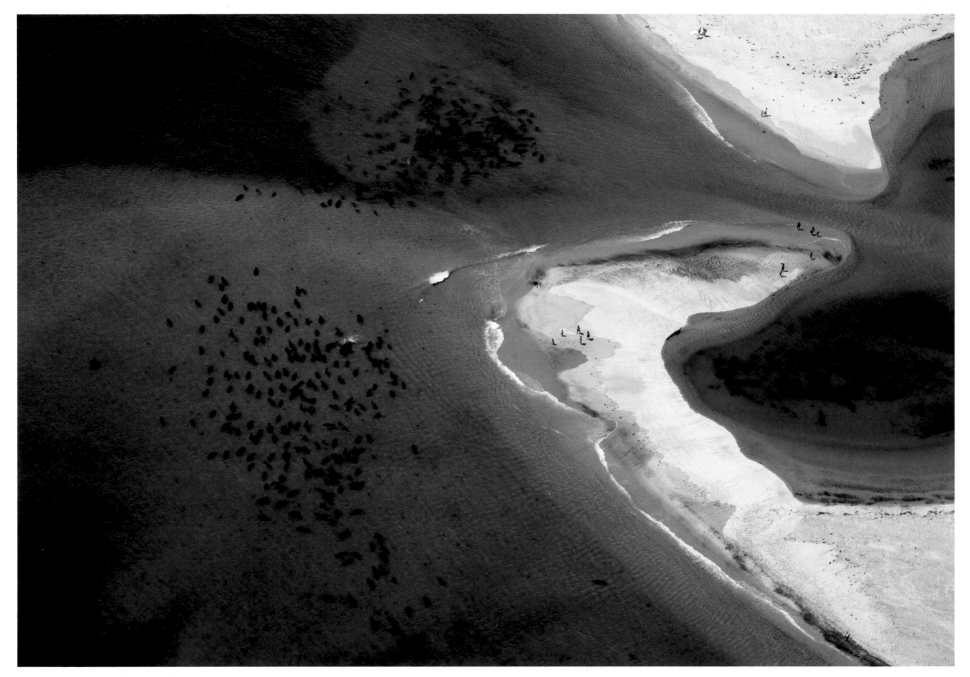

South Island seals, Chatham. There was a great white shark sighting near here on this day.

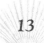

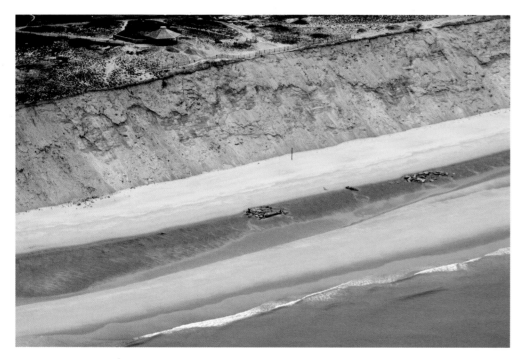

Marconi Wireless Station remains (1902), Wellfleet

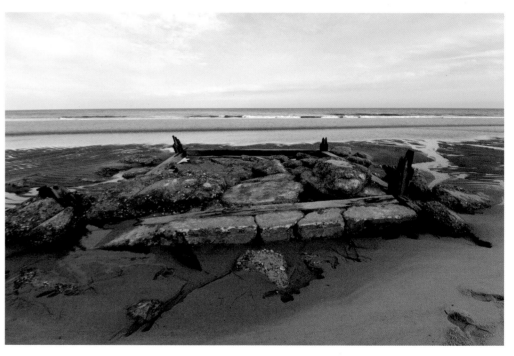

Marconi Wireless Tower foundations, revealed in winter, 2011

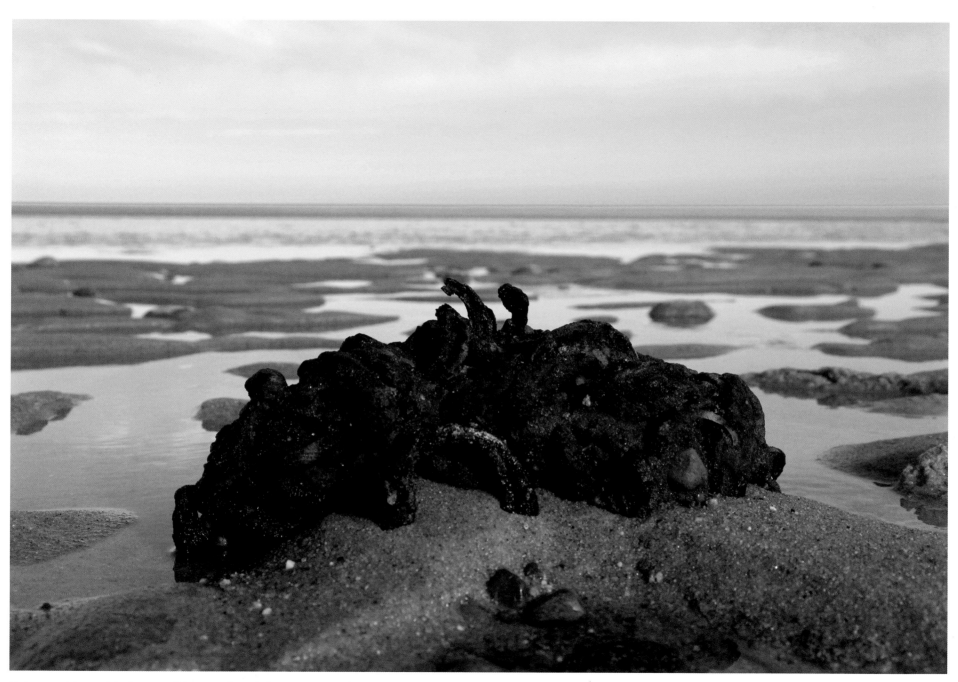

Unknown shipwreck ballast, possibly an anchor chain or scrap metal

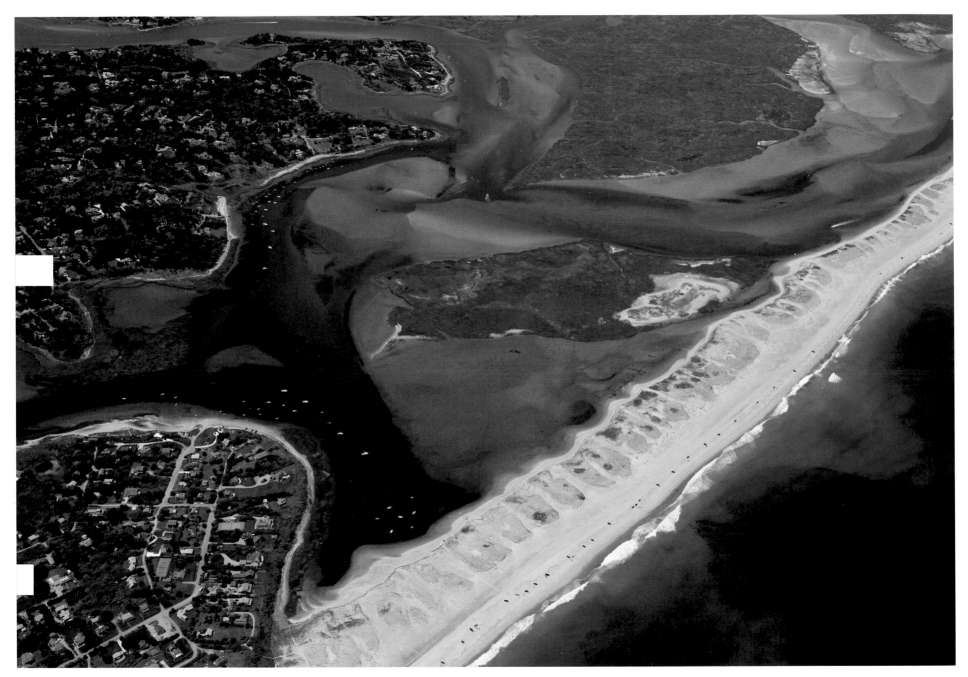

Nauset Harbor aerial, Orleans

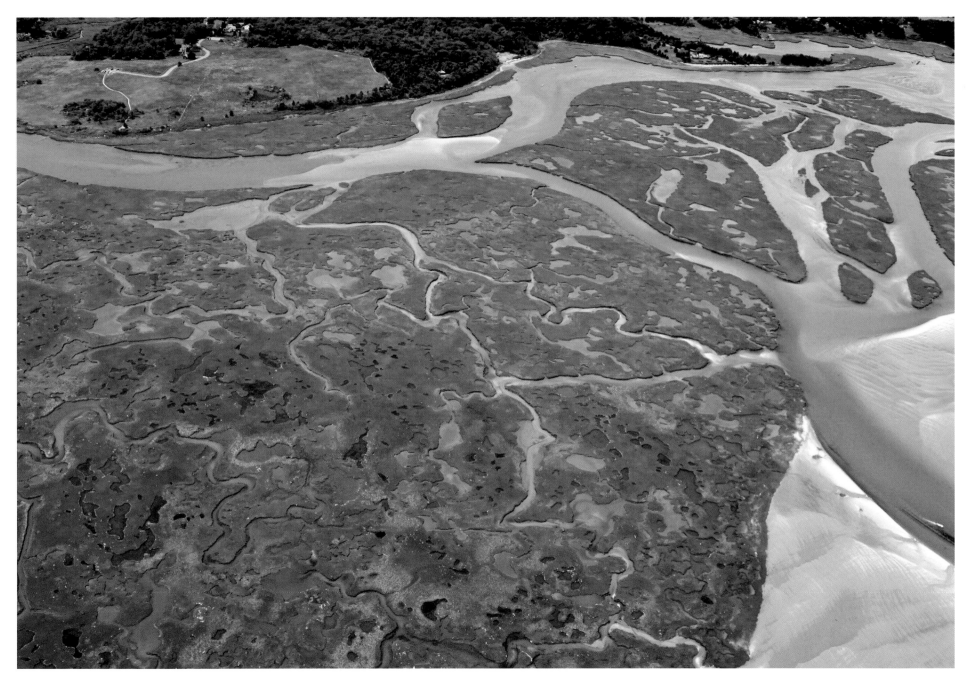

Nauset Harbor aerial, Eastham with Fort Hill at the top

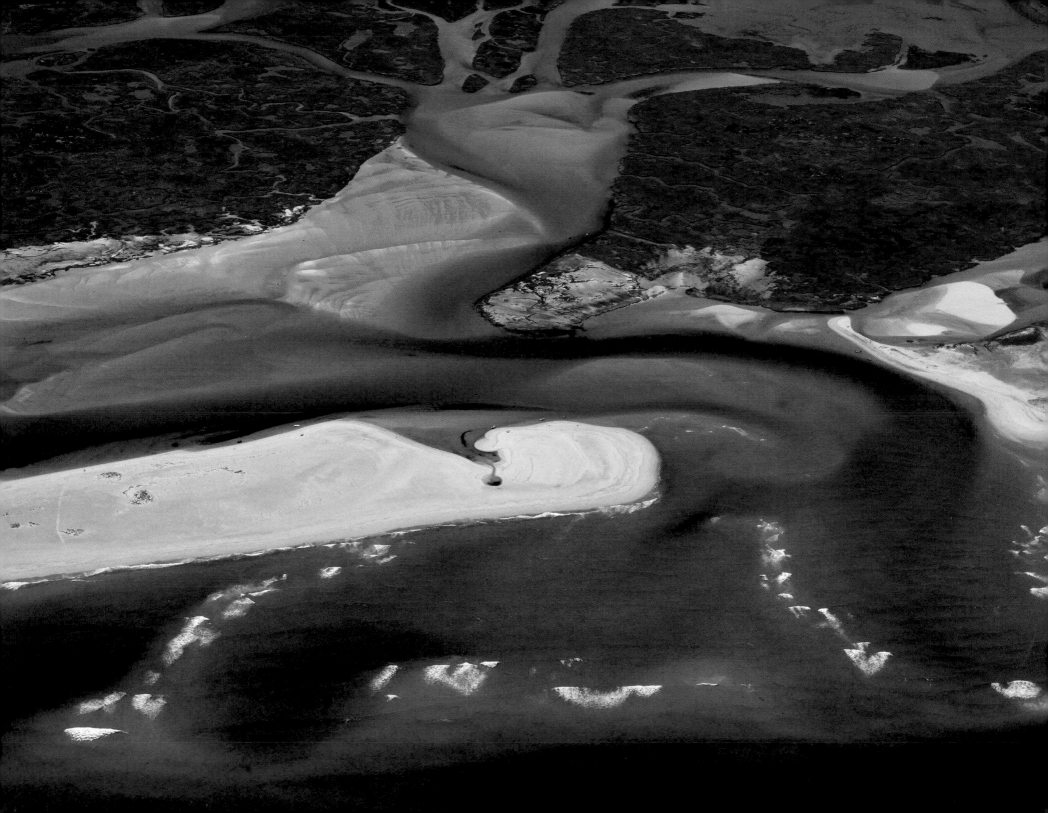

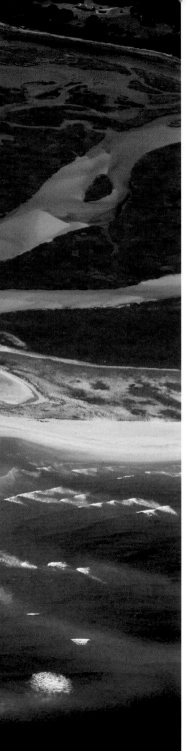

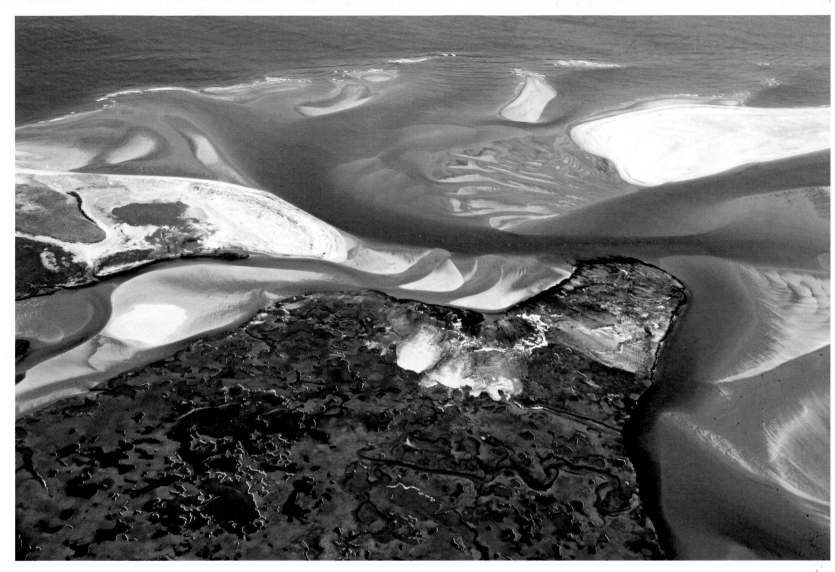

Nauset Marsh looking out to sea, Eastham

Nauset Marsh aerial. Henry Beston's "Outermost House," which was taken in the Blizzard of '78, would have been just out to sea of the left sandpit.

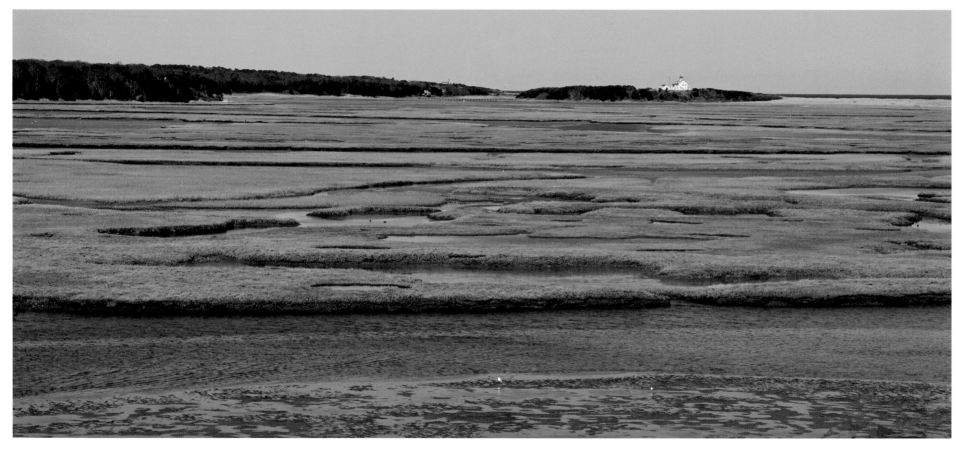

Nauset Marsh panorama, Eastham

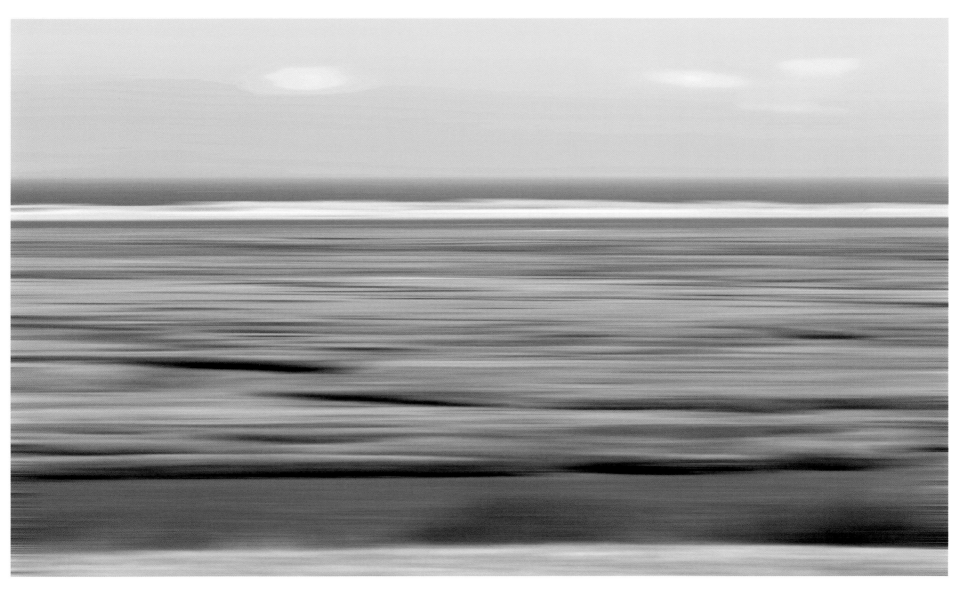

Nauset Marsh panorama abstract, Eastham

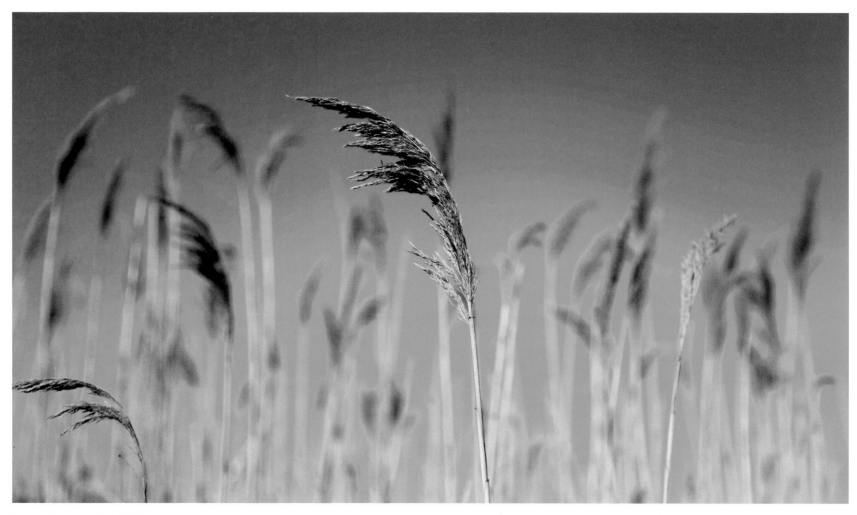

Sunny Marsh at Fort Hill, Eastham

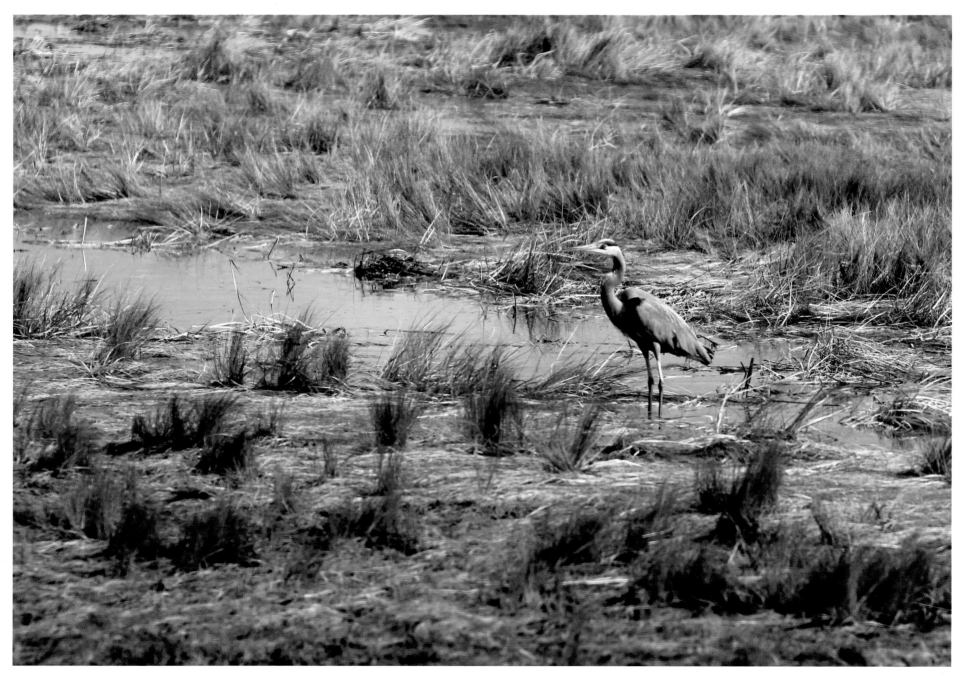

Great Blue Heron at Fort Hill, Eastham

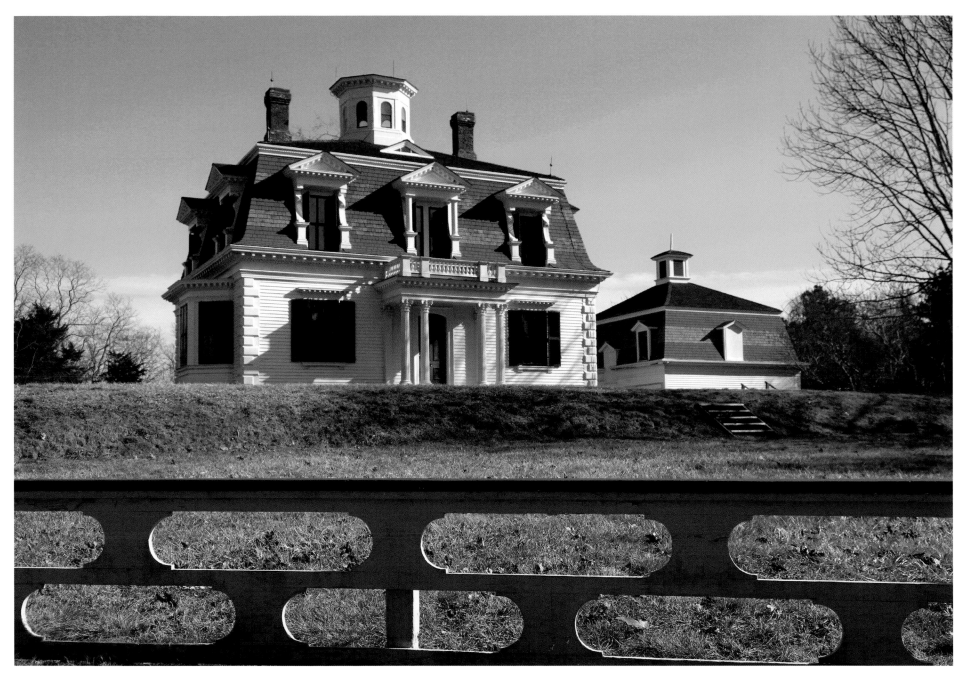

Whaling Captain Edward Penniman's house, built in the French Second Empire style in 1868 and the first in Eastham to have indoor plumbing

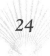

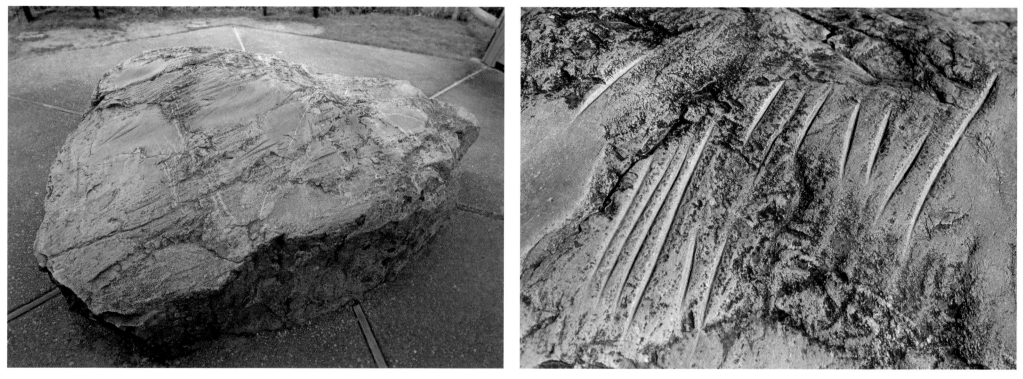

Native American sharpening rock moved from the marsh below Fort Hill in Eastham.

Native American sharpening rock detail, Eastham

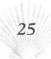

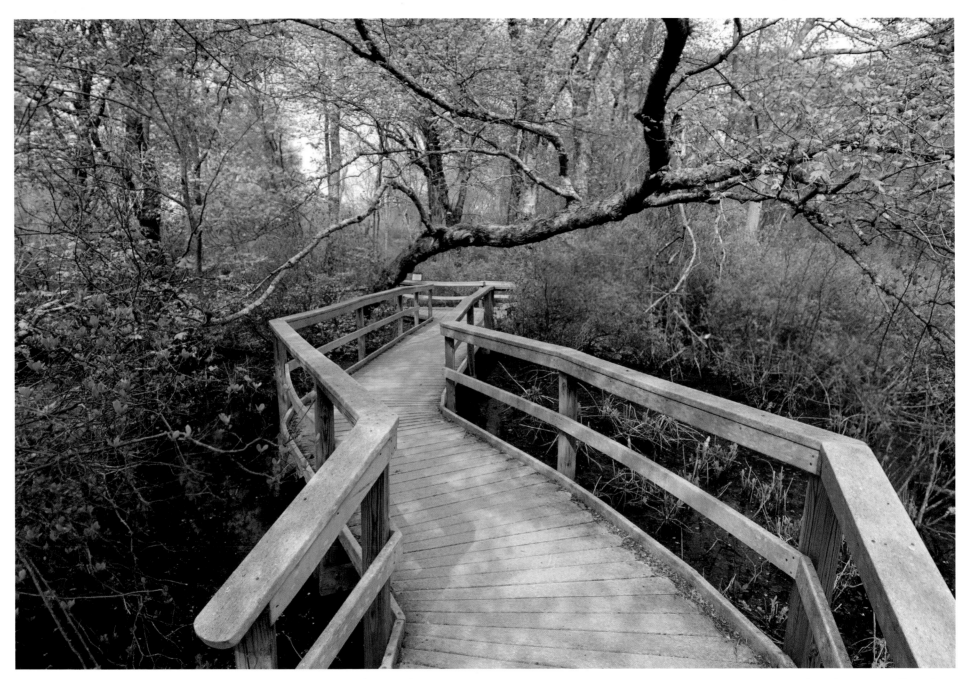

Red Maple Swamp Trail, Eastham

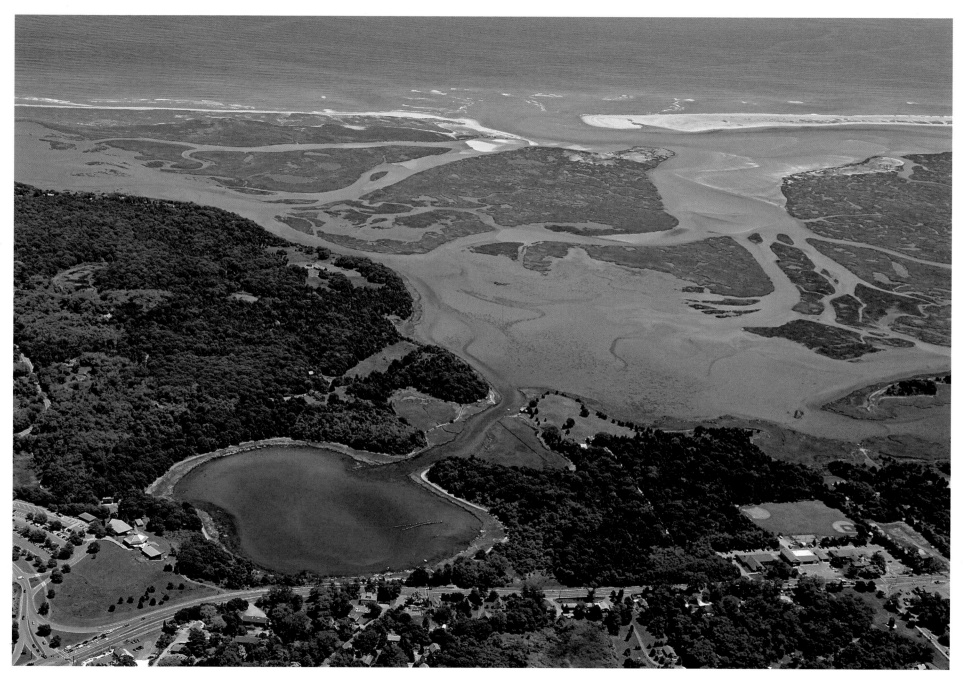

The National Park Services Salt Pond Visitor Center and surroundings, Eastham

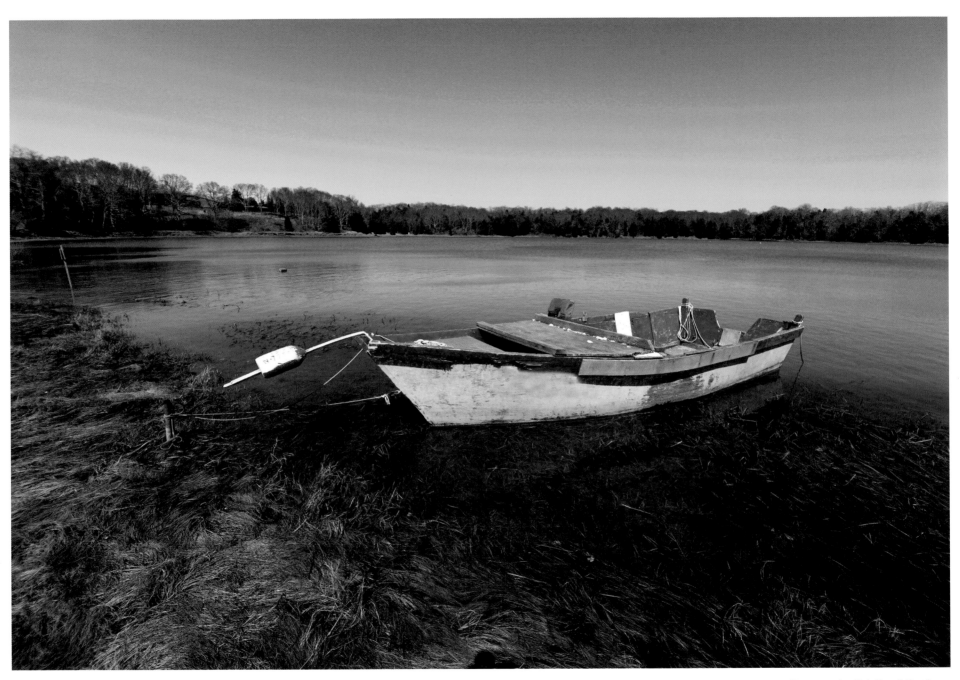

Dorey at the Salt Pond, Eastham

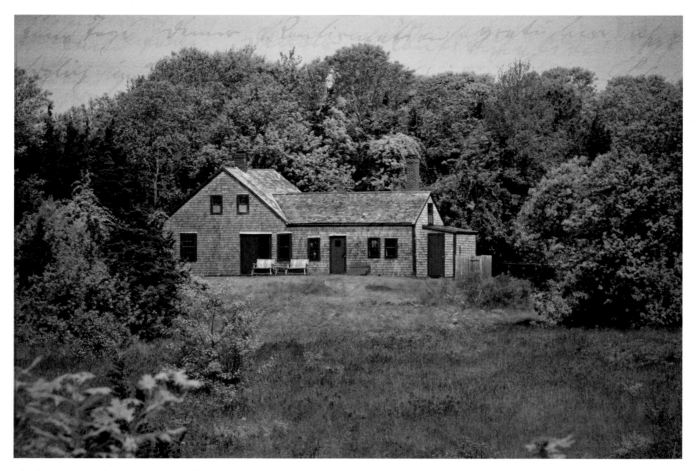

The house in Eastham that was the inspiration for the book *The House on Nauset Marsh* by Wyman Richardson

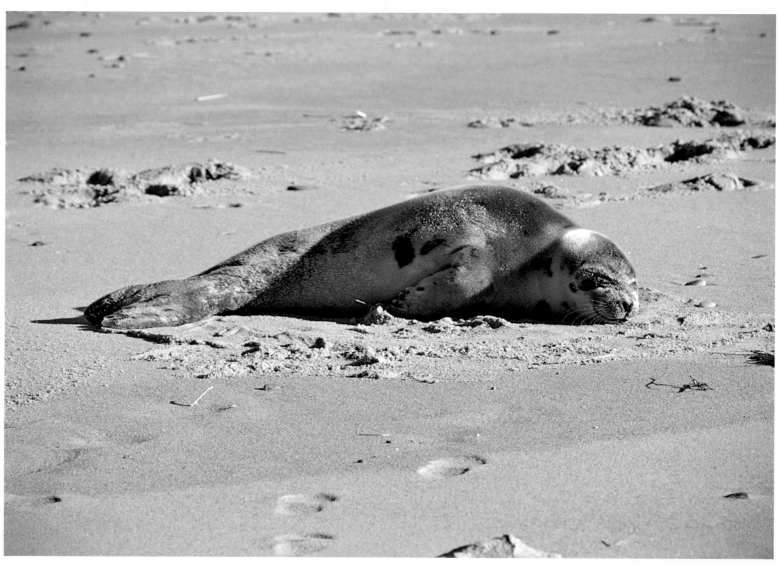

Grey seal pup at Nauset Beach, Orleans

A secluded and little-known public beach at Bound Brook Island, Wellfleet

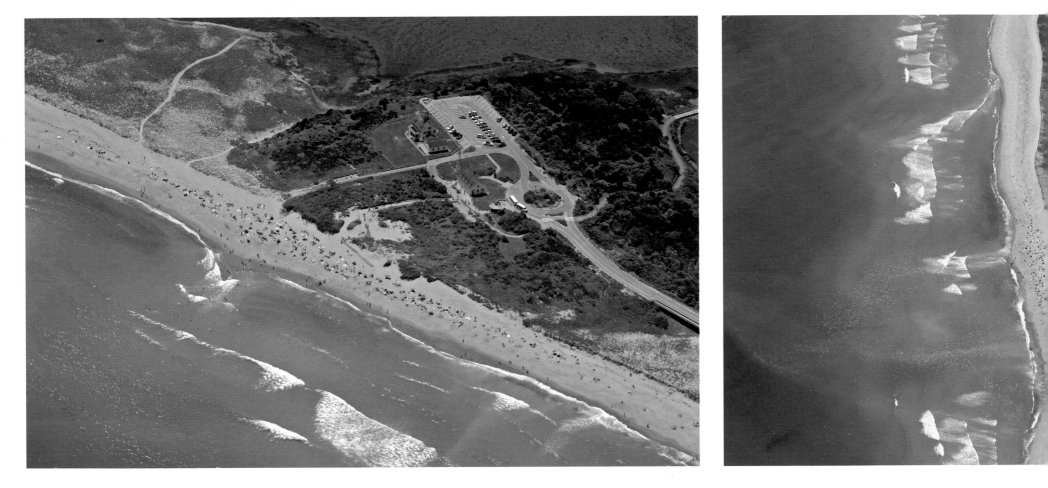

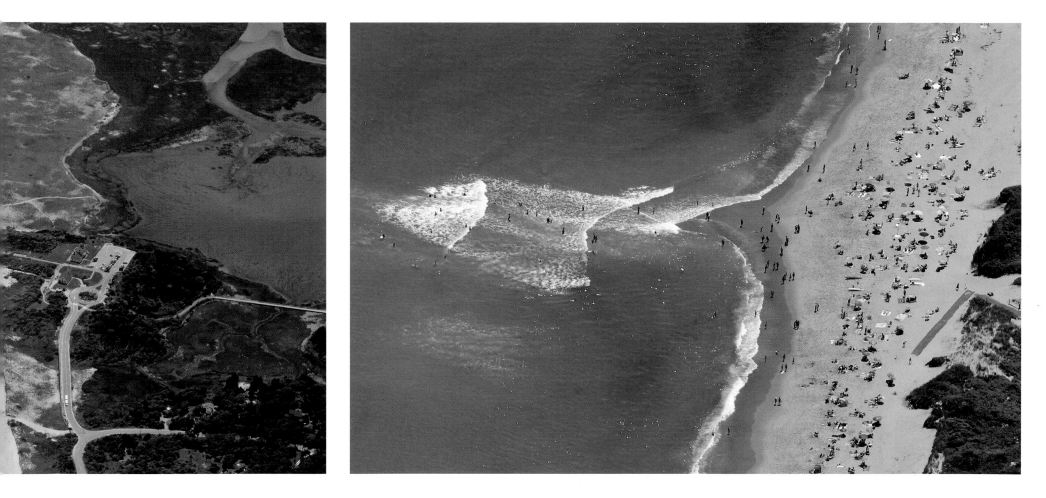

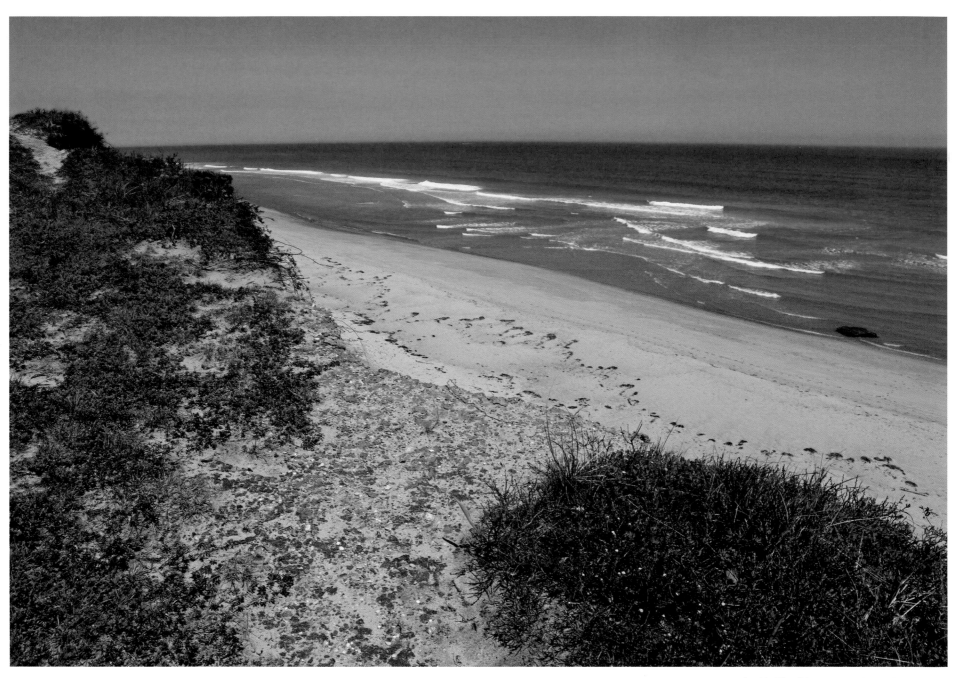

The bluffs of Coast Guard Beach, Eastham

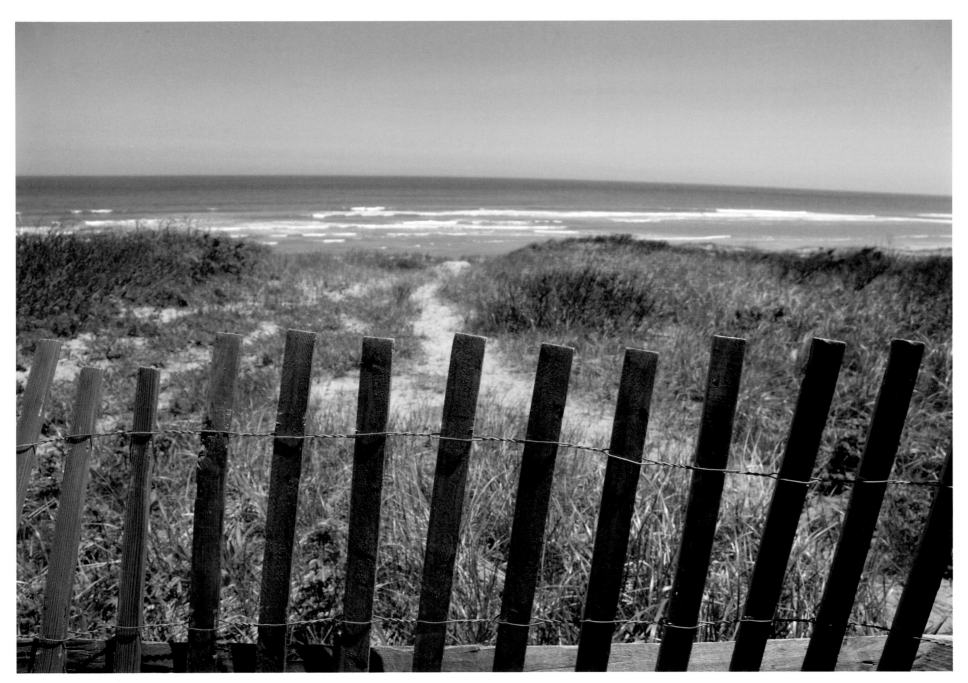

Coast Guard Beach snow fence, Eastham

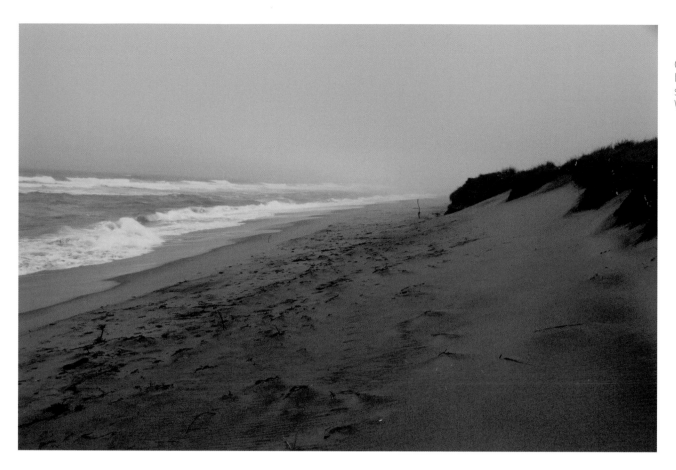

Off-season storm at Coast Guard Beach. It was a storm like this that uncovered the Carns archaeological site near this spot. The site dates back to the Early Woodland Period, approximately 2100 years ago.

Carns archaeological site pottery. Baskets were used to shape the wet clay, giving the exterior this pattern.

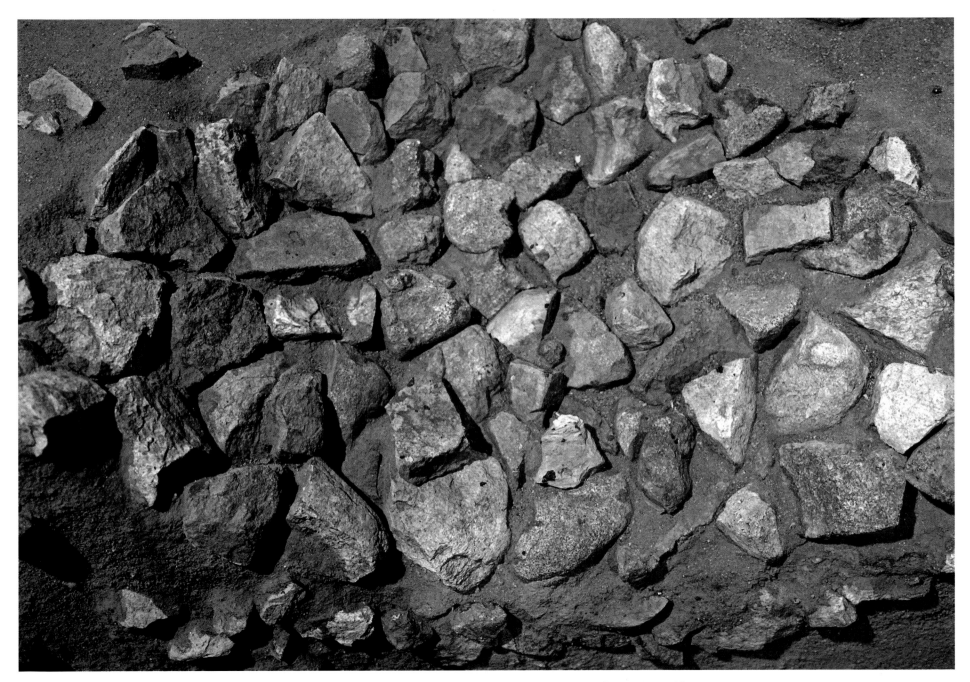

Carns archaeological site. This fire-cracked rock resulted when stones were used to line hearths at a Native American fire 2100 to 1100 years ago

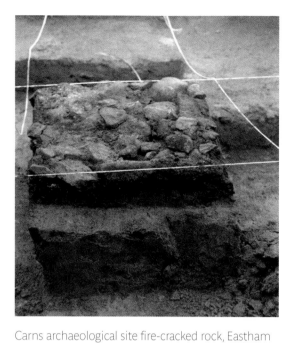

Carns archaeological site fire-cracked rock, Eastham

Carns archaeological site pottery, Eastham

Carns archaeological site stone tool, Eastham

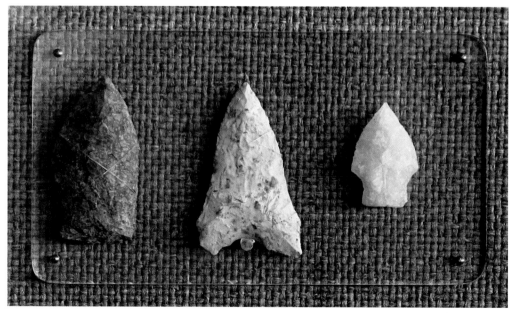

Stone tools on display at the Provincelands visitor center, Provincetown

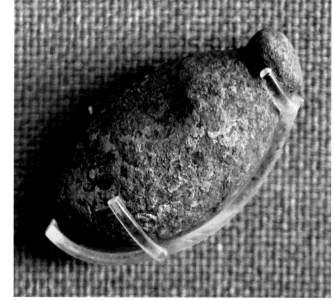

Fishing weight on display at the Provincelands visitor center, Provincetown

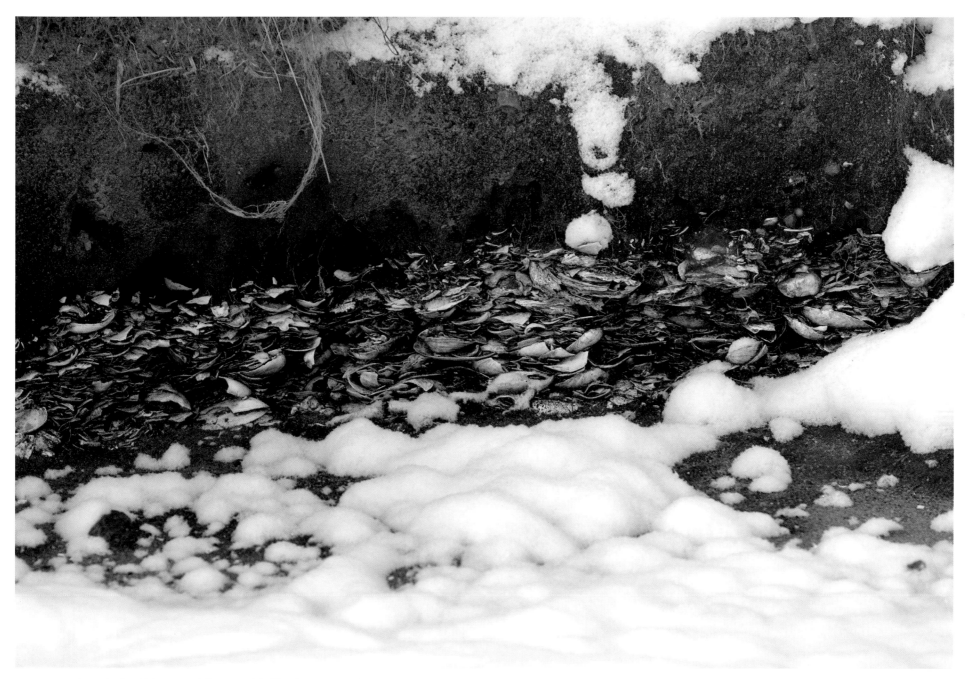

Native American shell midden crumbling on a bluff in the Cape Cod National Seashore. Native Americans deposited shells in heaps. The calcium carbonate in the shell preserves organic material, such as textile, seeds, and nut husks, making for potentially valuable historical sites.

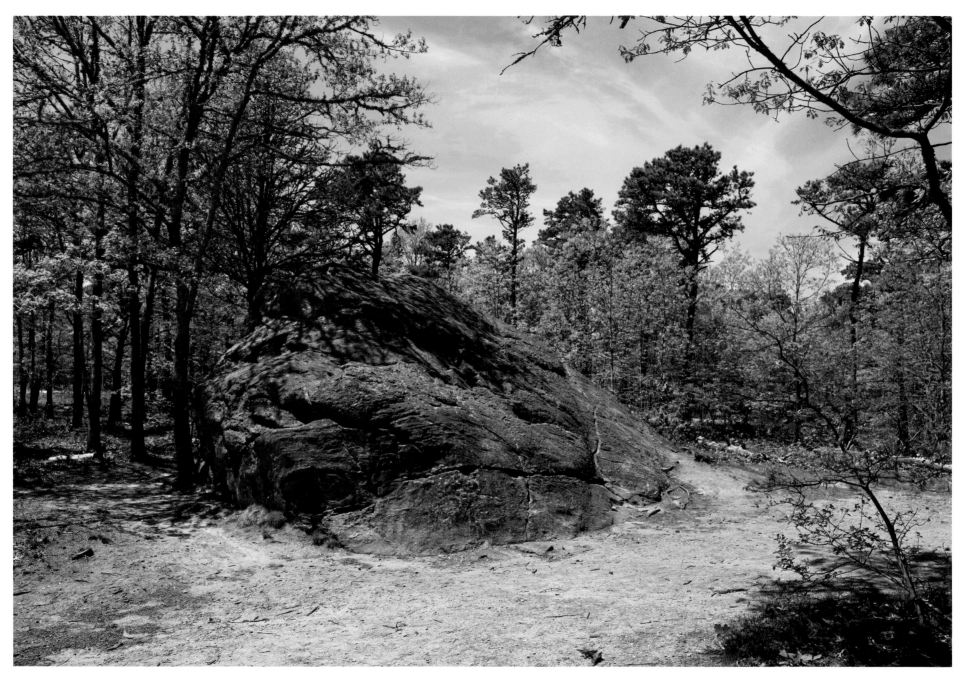

Doane Rock, Eastham, the largest glacial erratic boulder on Cape Cod

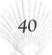

40

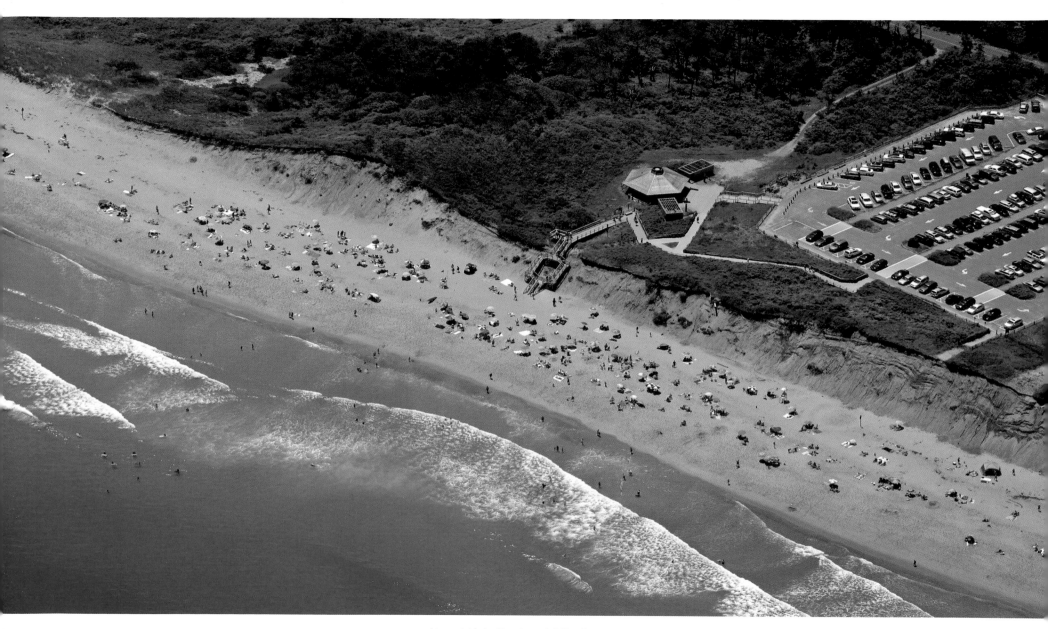

Nauset Light Beach aerial, Eastham

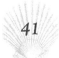

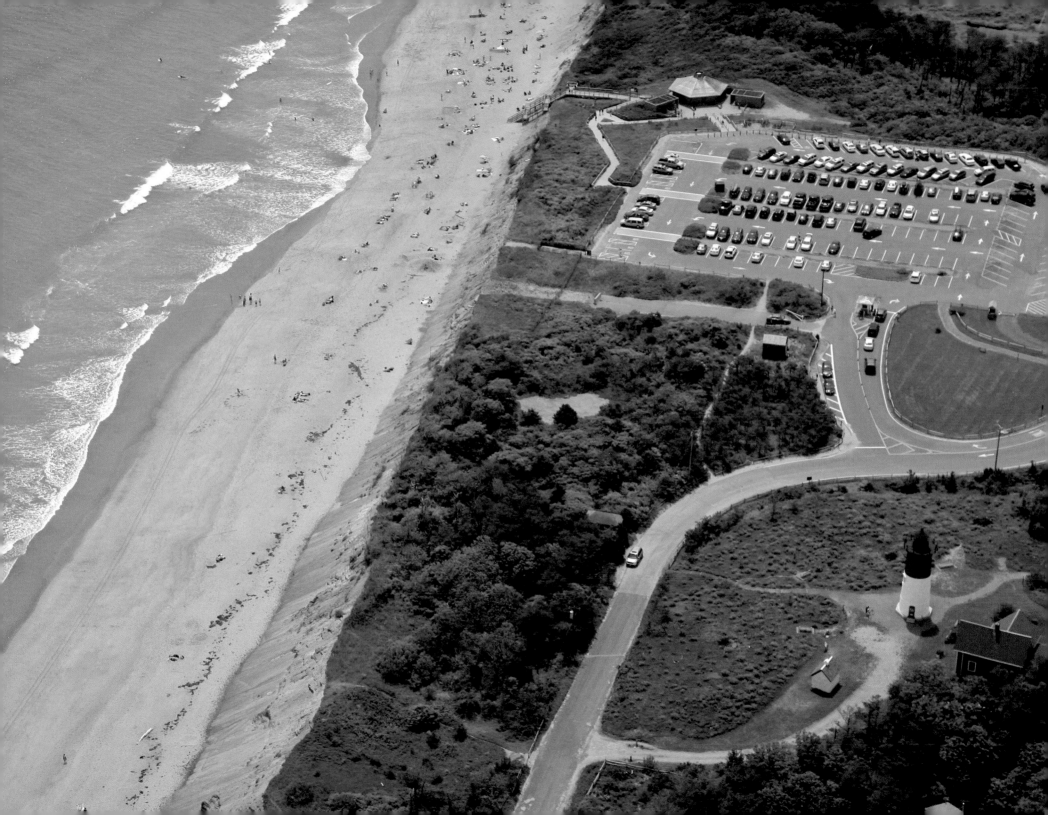

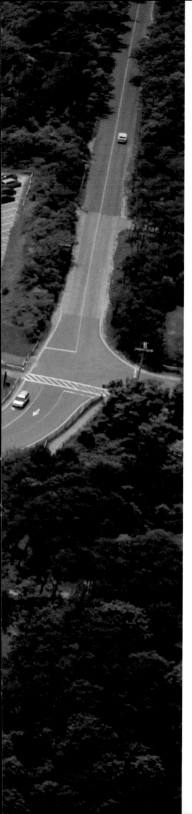

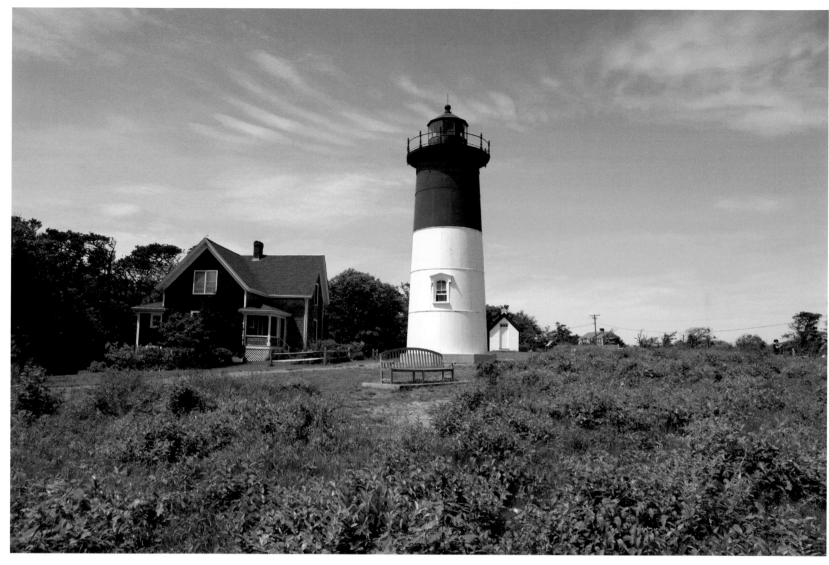

Nauset Lighthouse, Eastham. The tower was constructed as one of the Chatham Twin Lights in 1877 and subsequently was moved to Eastham in 1923.

Nauset Lighthouse aerial, Eastham

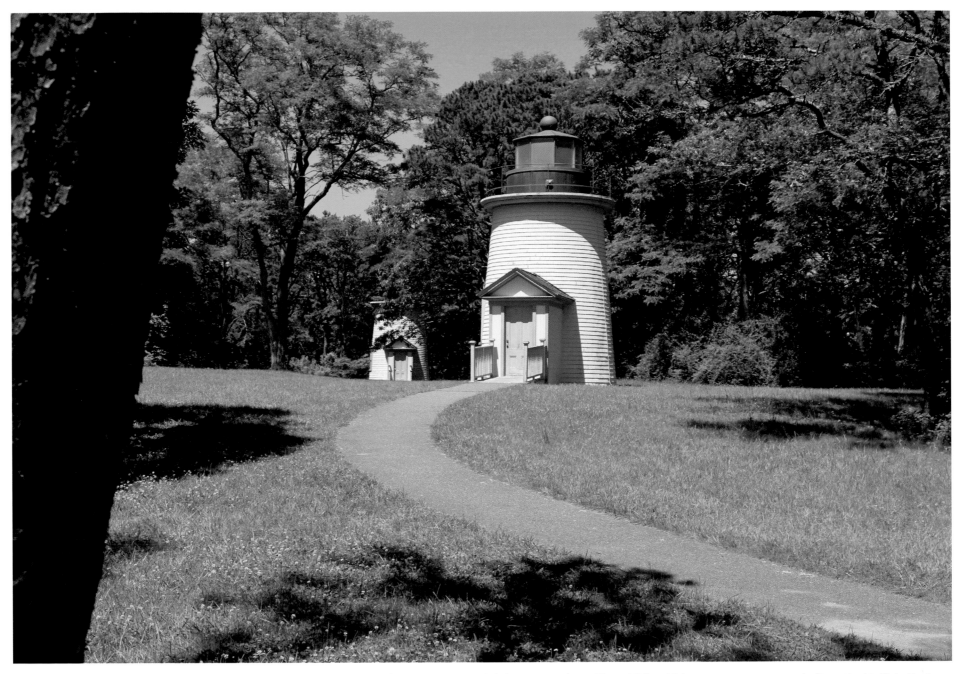

Two of the Three Sisters Lighthouses, Eastham. Three 15-foot high masonry towers were built on the bluffs in Eastham in 1837. The lights soon gained the nickname "The Three Sisters," because from sea they looked like women in white dresses with black hats. After being decommissioned and spending time as private residences the lighthouses were purchased by the National Park Service in 1965 and moved about a quarter of a mile inland from their original location.

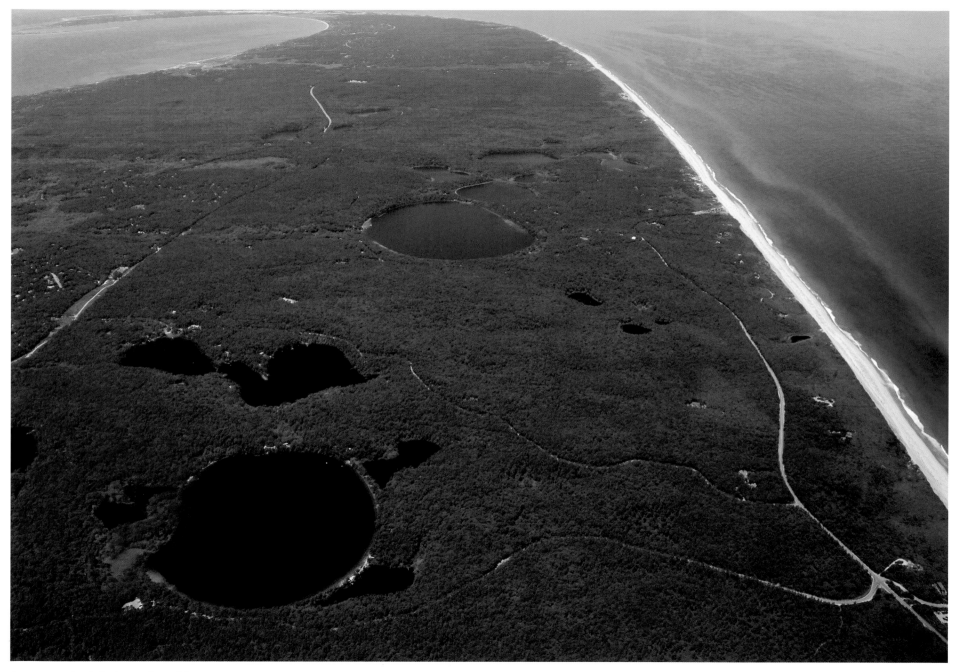

Outer Cape kettle hole ponds, Wellfleet

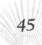

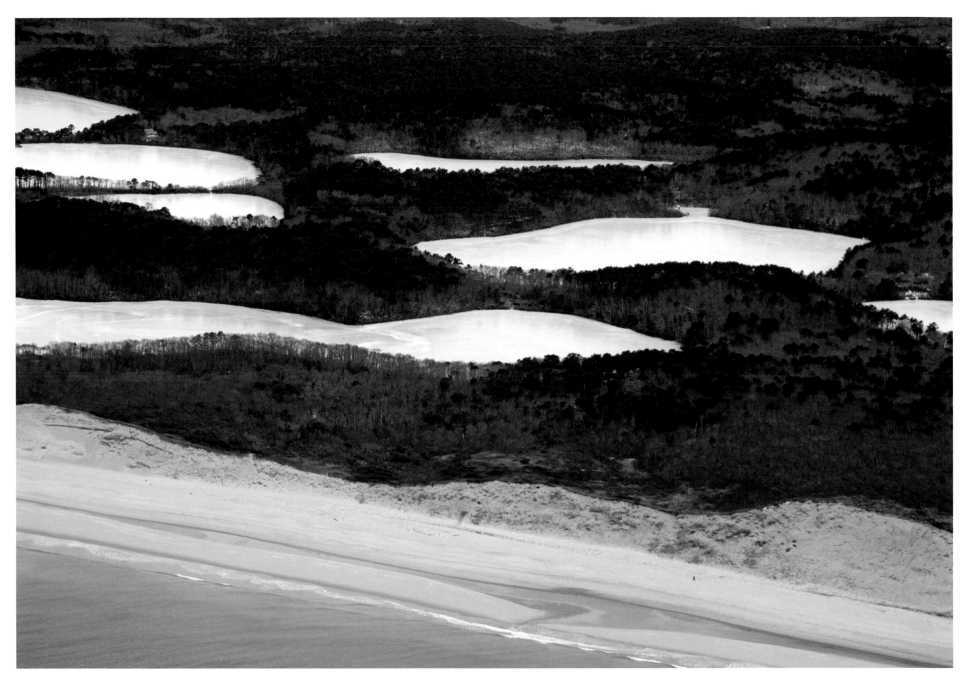

Wellfleet's Great Pond in winter

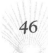

46

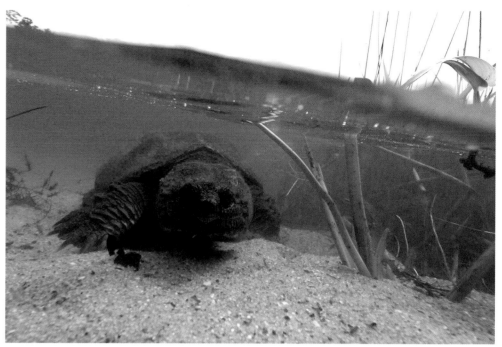
A snapping turtle swims toward the camera.

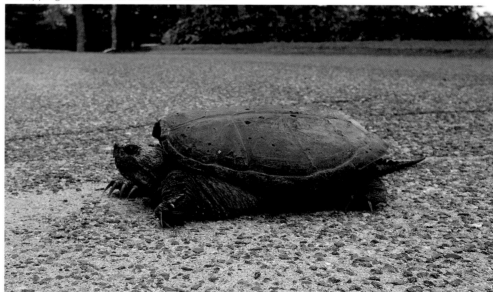
A snapping turtle crosses a road from a nearby kettle hole.

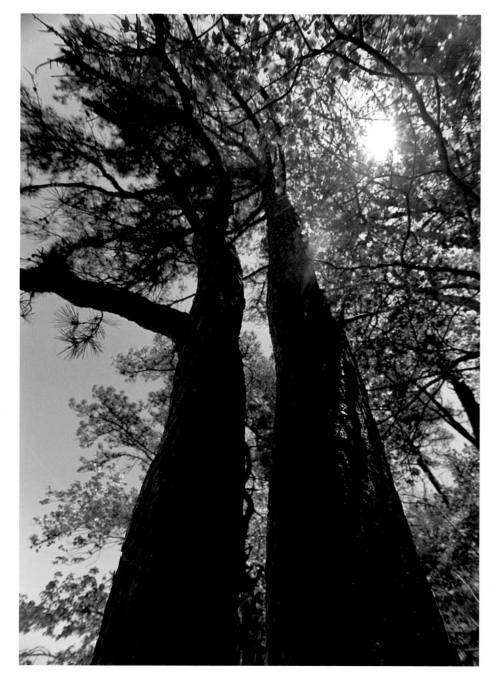
Sunlight filters through trees at Great Pond, Wellfleet.

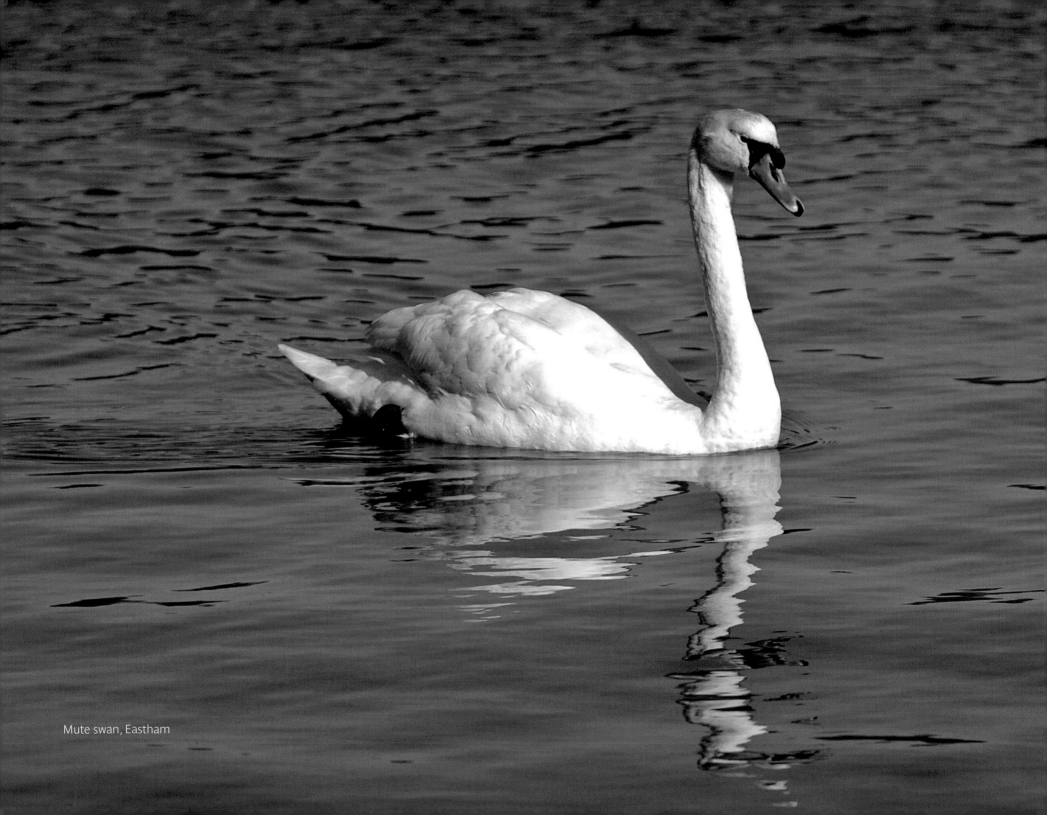

Mute swan, Eastham

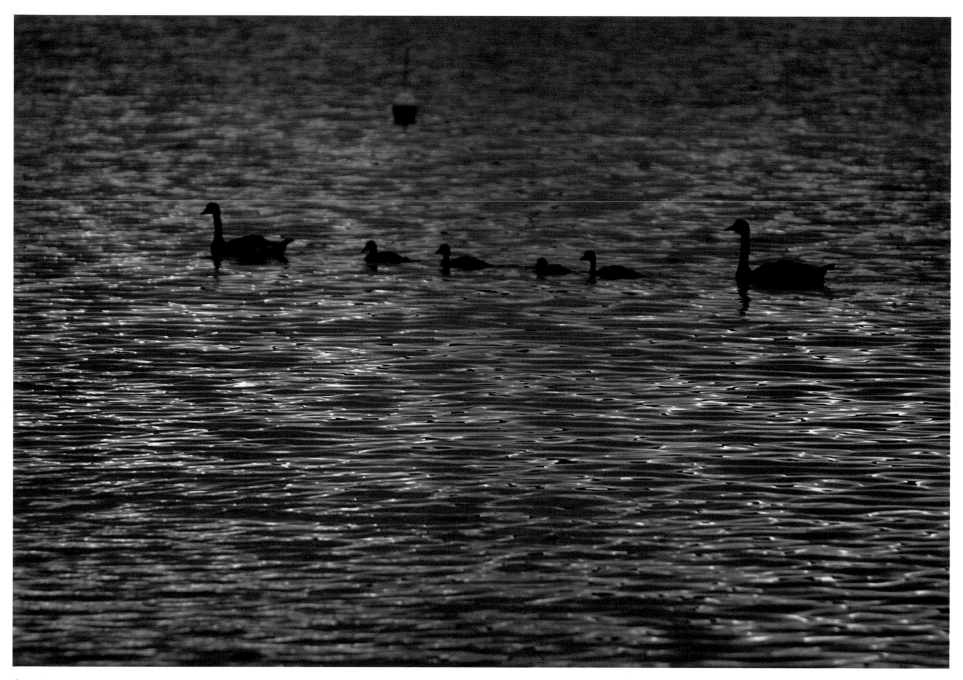

Canada geese

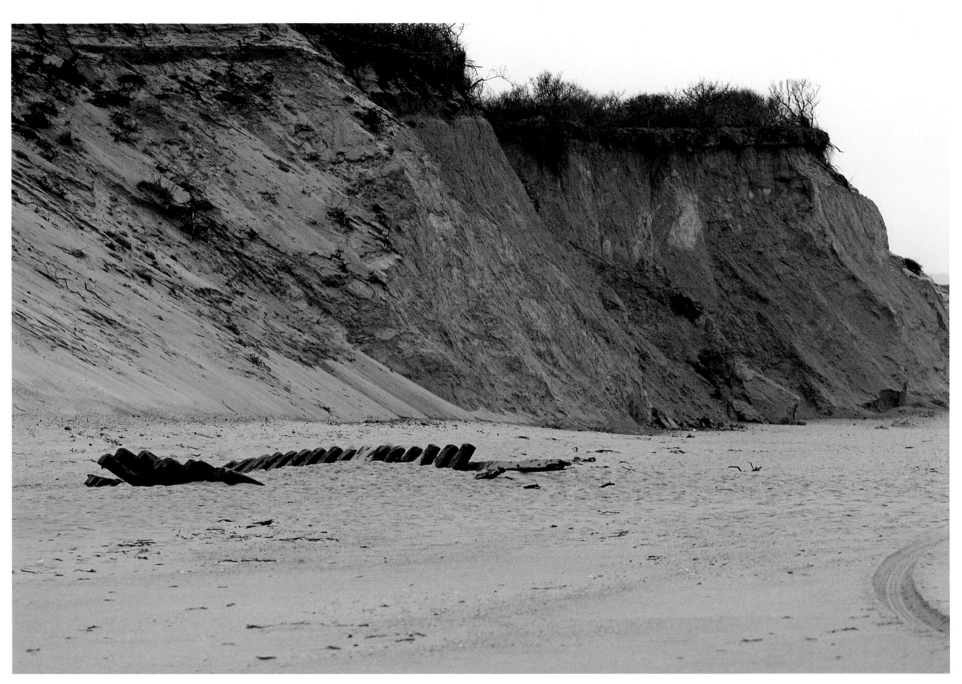

A shipwreck unearthed in the winter of 2009 at Lecount Hollow, Wellfleet

Part of an old-fashioned leather shoe in the sands at Marconi Beach, Wellfleet

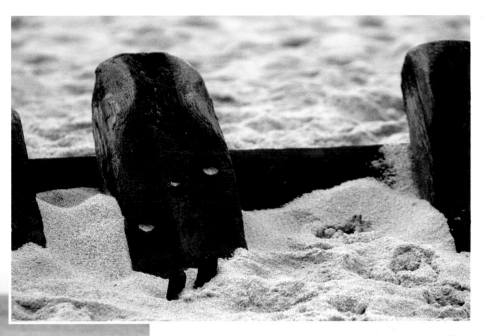

Shipwreck detail, Wellfleet

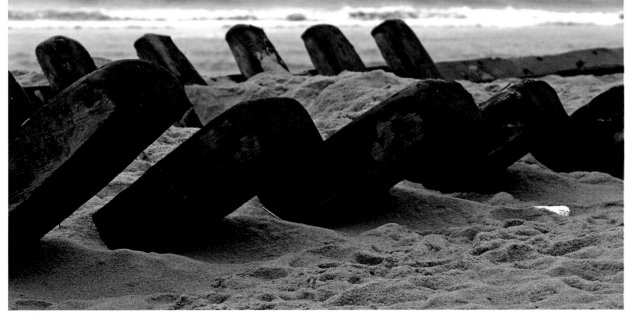

Shipwreck detail, Wellfleet

51

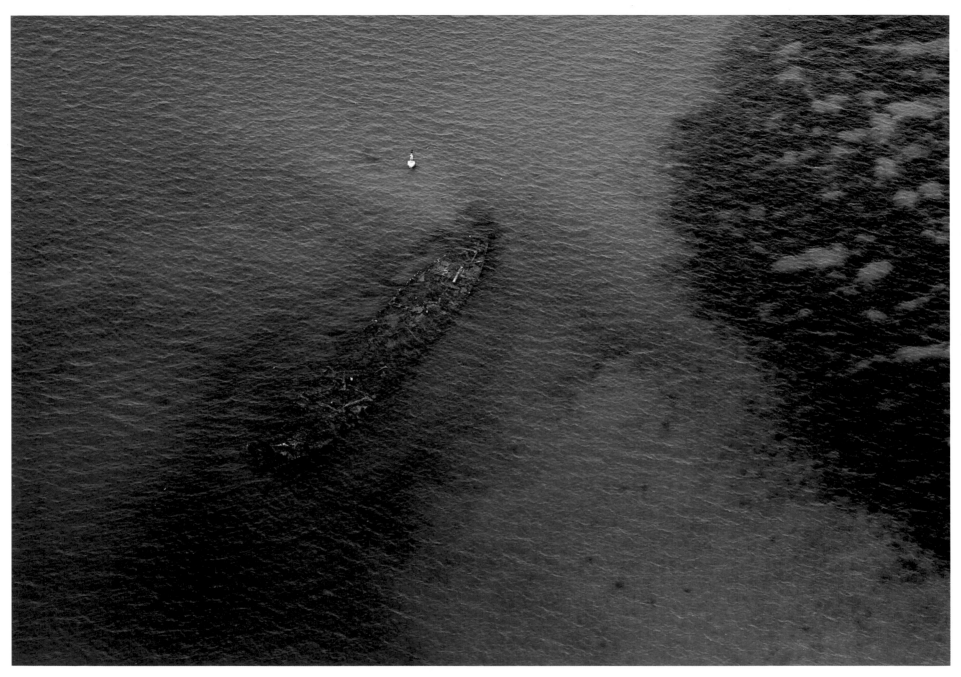

The *SS James Longstreet*, also known as the "target ship," broke her back off Long Island and was later towed to Cape Cod. She was deliberately grounded 3.5 miles off Rock Harbor in Orleans in 1944 to be used as a target for military aircraft. Somewhere in the late 1990s the ship degraded so much that it was no longer visible at Rock Harbor, Orleans, but at low tide it is still quite a site from the air.

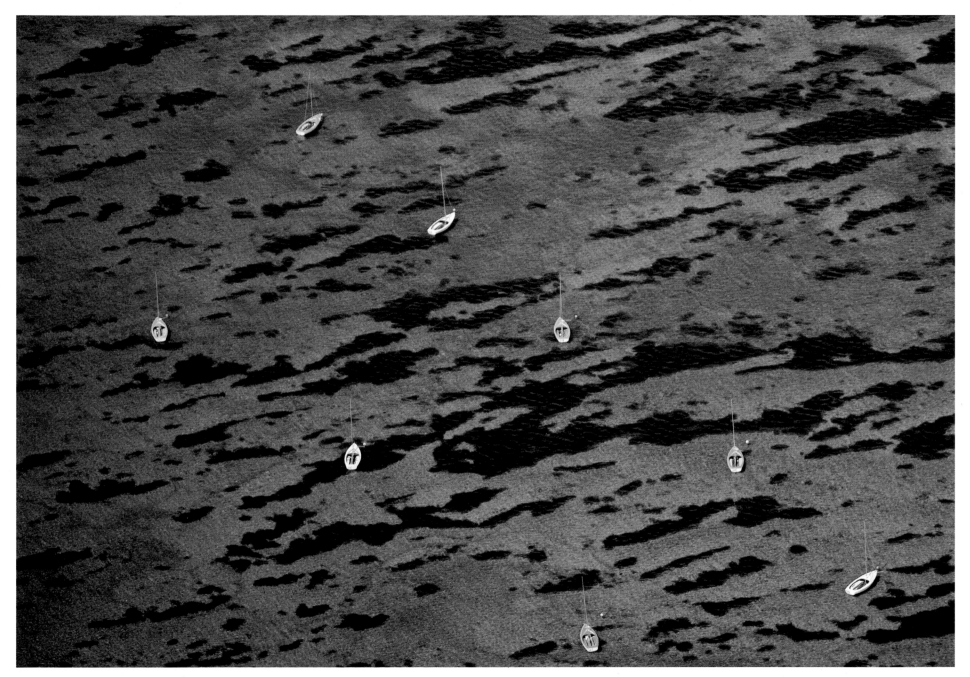

The flats of Cape Cod Bay with sailboats dotting the surface, Wellfleet

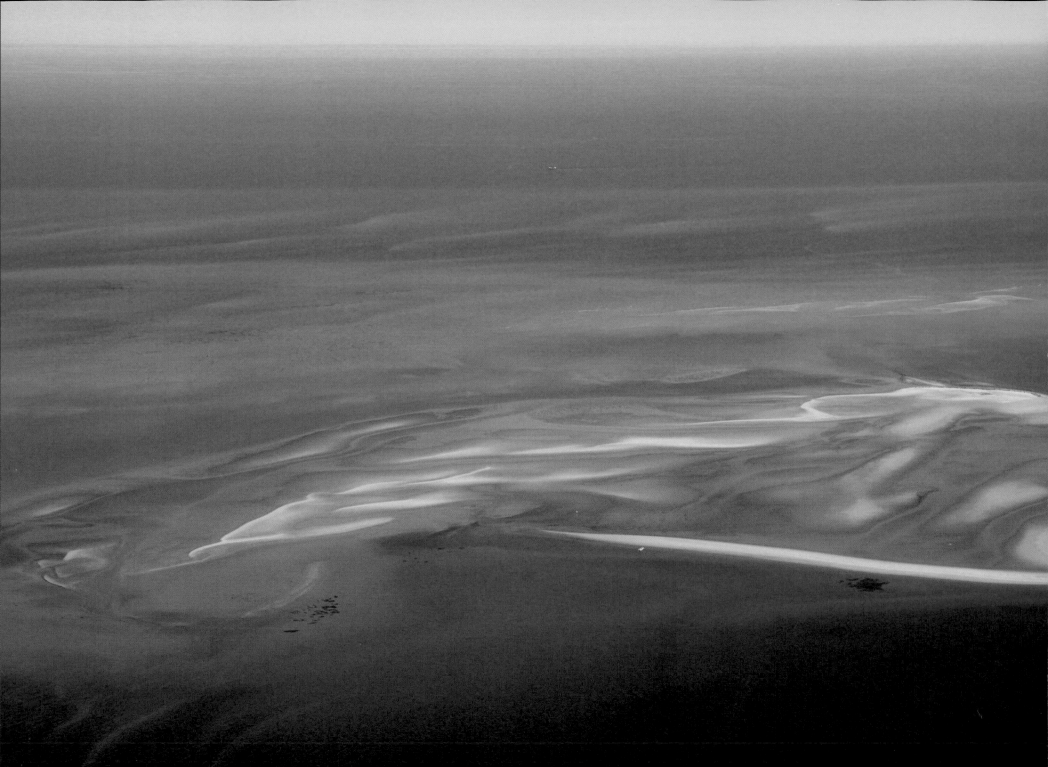

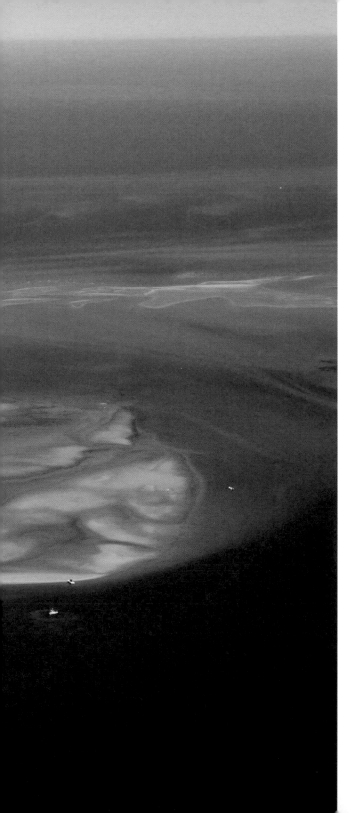

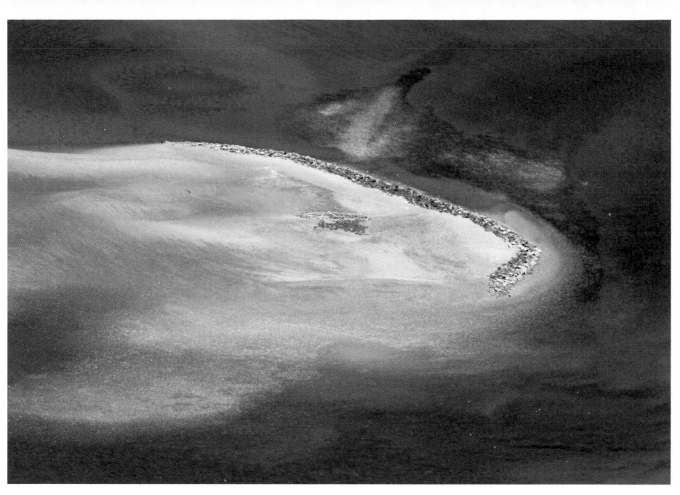

Billingsgate Lighthouse tower remains, Wellfleet. In 1822, Cape Codders erected a lighthouse on the southern tip of the island to help mariners navigate along the shores of Cape Cod Bay. The tower was discontinued in 1922.

Billingsgate Island, Wellfleet. In the late 1800s, this island off Jeremy Point on Wellfleet's north shore was about 60 acres in size. The island supported a small fishing community, which included about 30 horses, a store, a school, and livestock. The island was abandoned in the early 1900s and completely submerged by the 1940s.

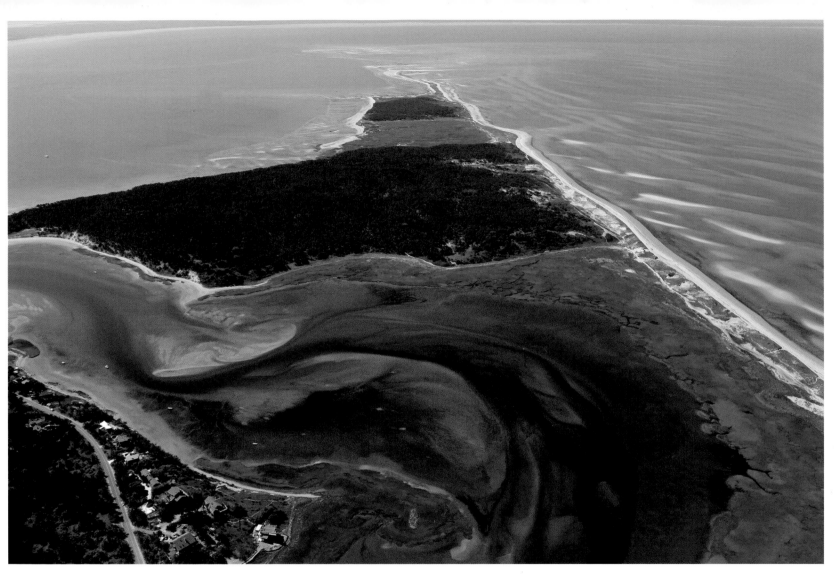

Jeremy Point and Great Island (foreground), Wellfleet. The trail along its length is a hearty 7-mile roundtrip.

Seals on the tip of Jeremy Point, Wellfleet

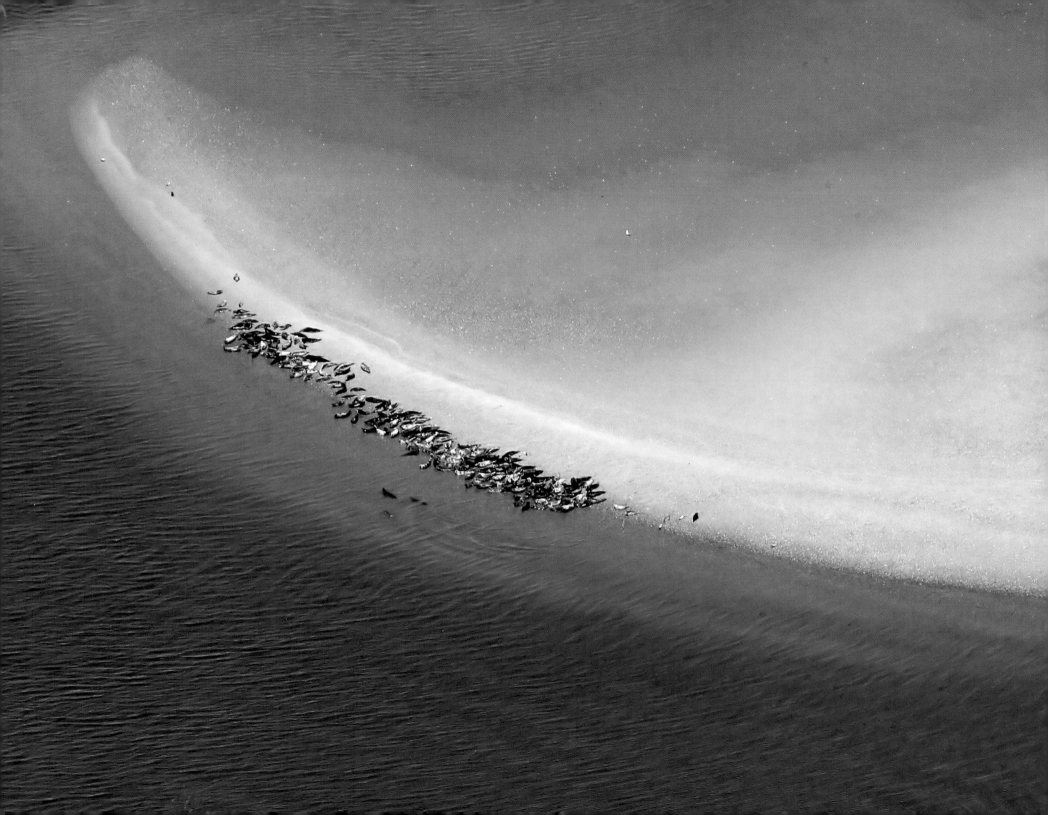

Pipe Stems from an 18th-century whaling tavern on Great Island, Wellfleet

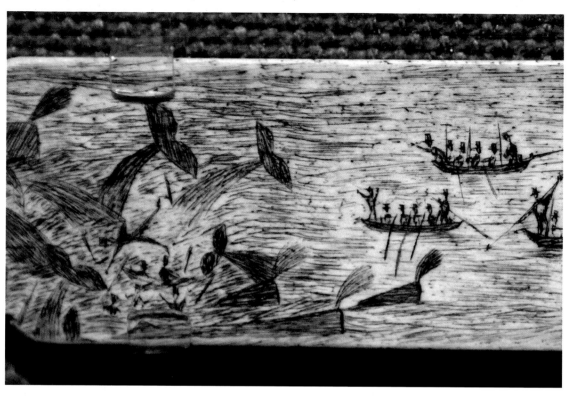

Wellfleet whaling scene scrimshaw, Salt Pond Visitor Center

Captain's whaling journal, Salt Pond Visitor Center

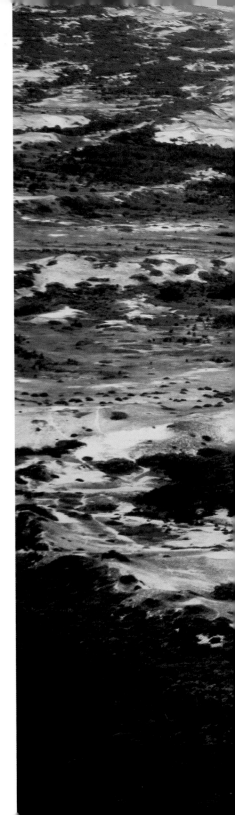

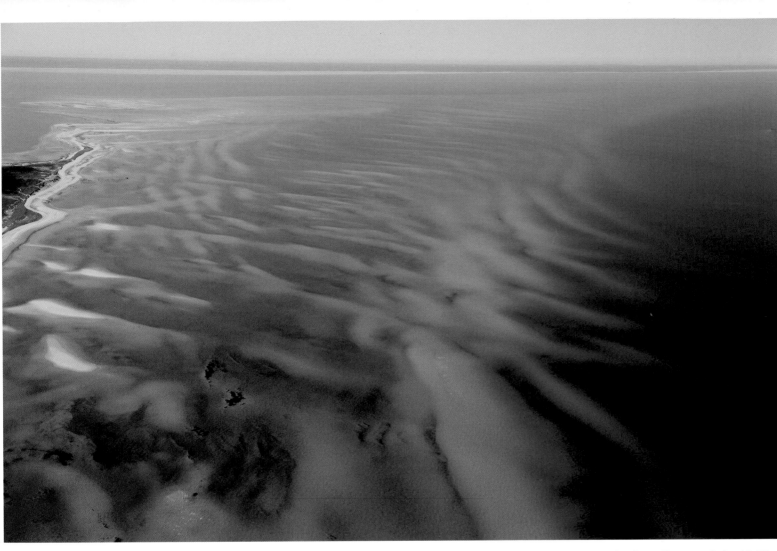

The flats off Jeremy Point, Wellfleet

Provincelands aerial, Provincetown. Somewhere in this landscape the pilgrims had their first drink from a fresh water spring in the New World, on their way to Plymouth.

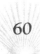

Provincelands oversand vehicle path.

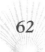

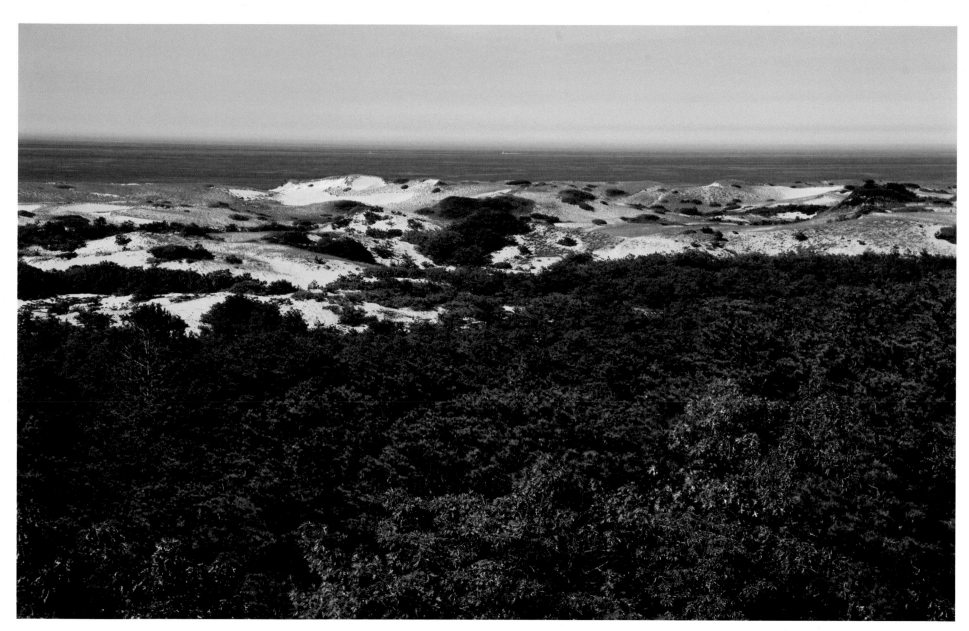

Provincelands dunes. This land was heavily wooded with soft and hardwoods when the Pilgrims visited here on their way to Plymouth. By the 1800s only sand remained.

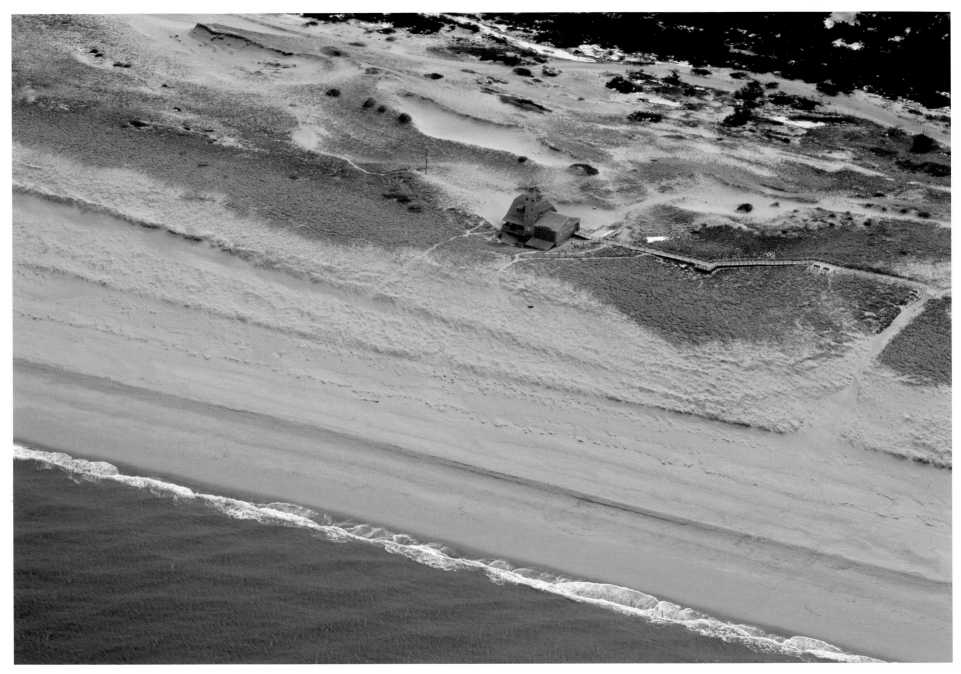

The Old Harbor Lifesaving Station was built in Chatham in 1897. It was purchased and moved by barge by the National Park Service in 1978, now serving as an historical museum about the lifesaving service, precursor to the Coast Guard.

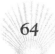

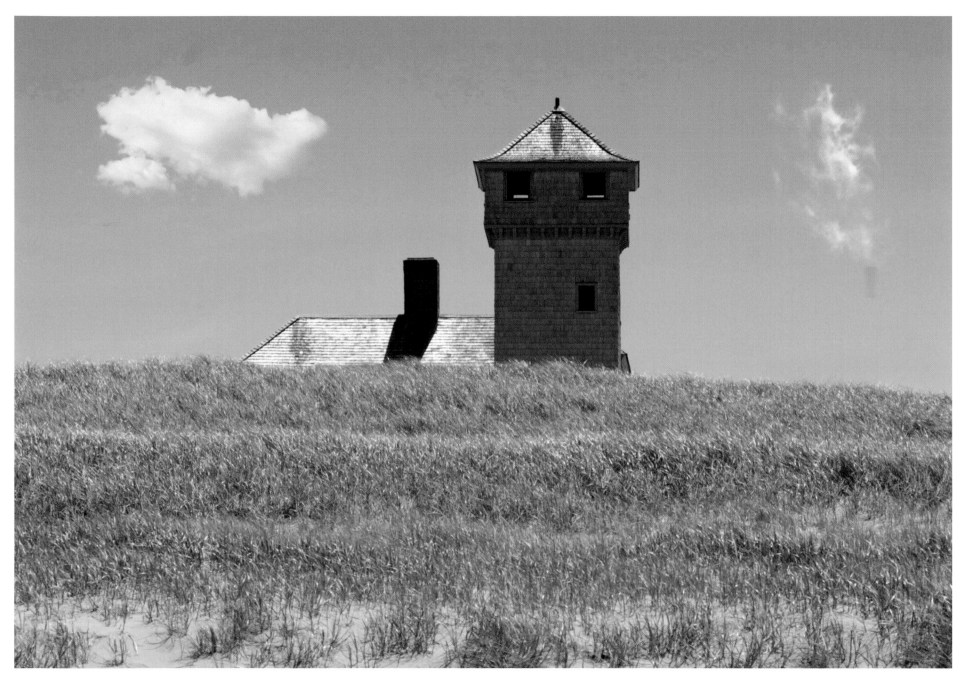

Old Harbor Lifesaving Station, Provincetown

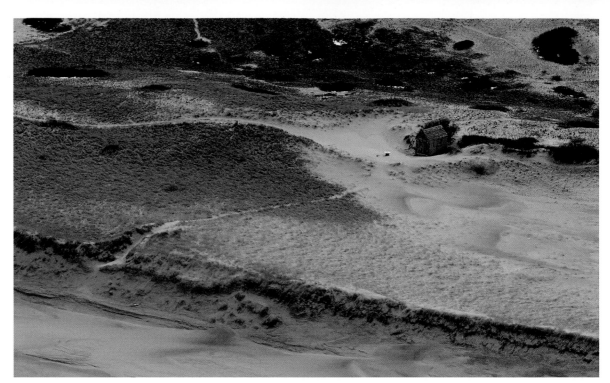

Aerial view of the dune shack of American poet/prose writer Harry Kemp (December 15, 1883 – August 5, 1960), also known as the "Poet of the Dunes," Provincetown.

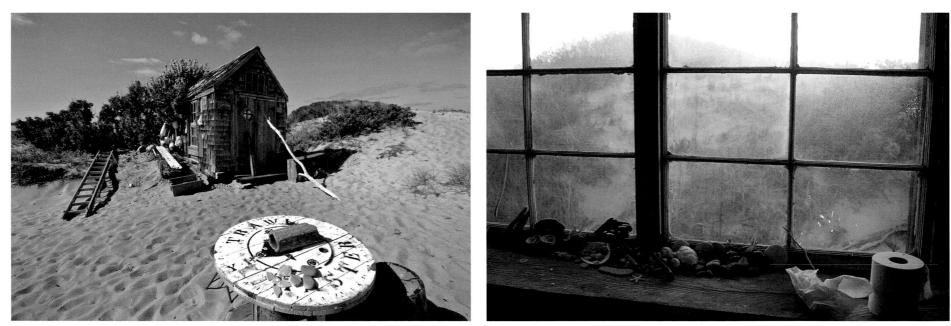

Harry Kemp shack exterior and artifacts, Provincetown

Harry Kemp shack interior, Provincetown. The shack is owned by a private family and still in use today.

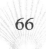

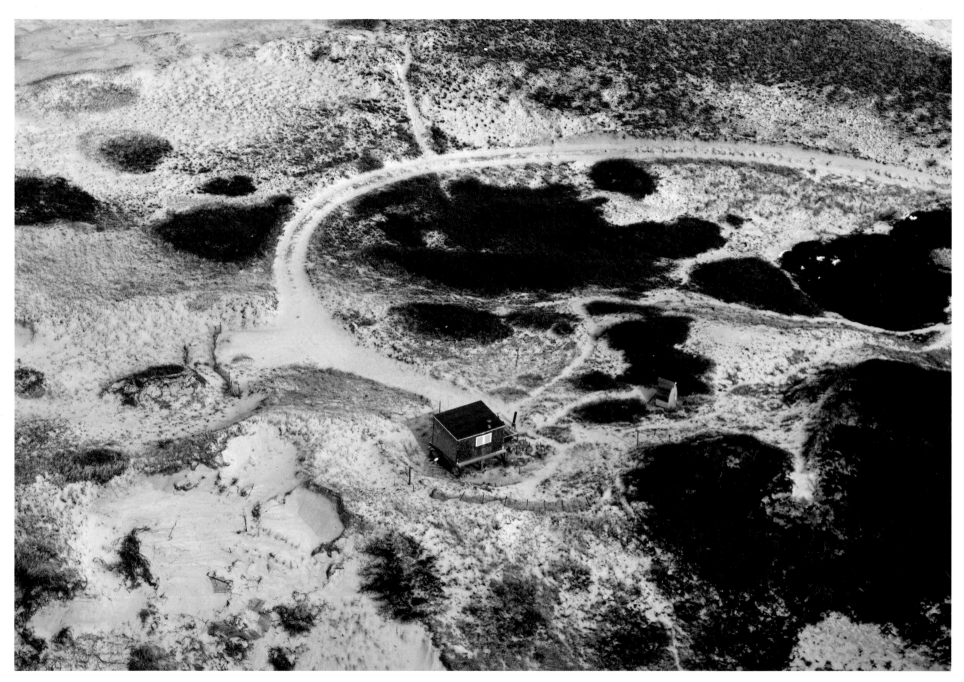

Euphoria dune shack aerial, Provincetown

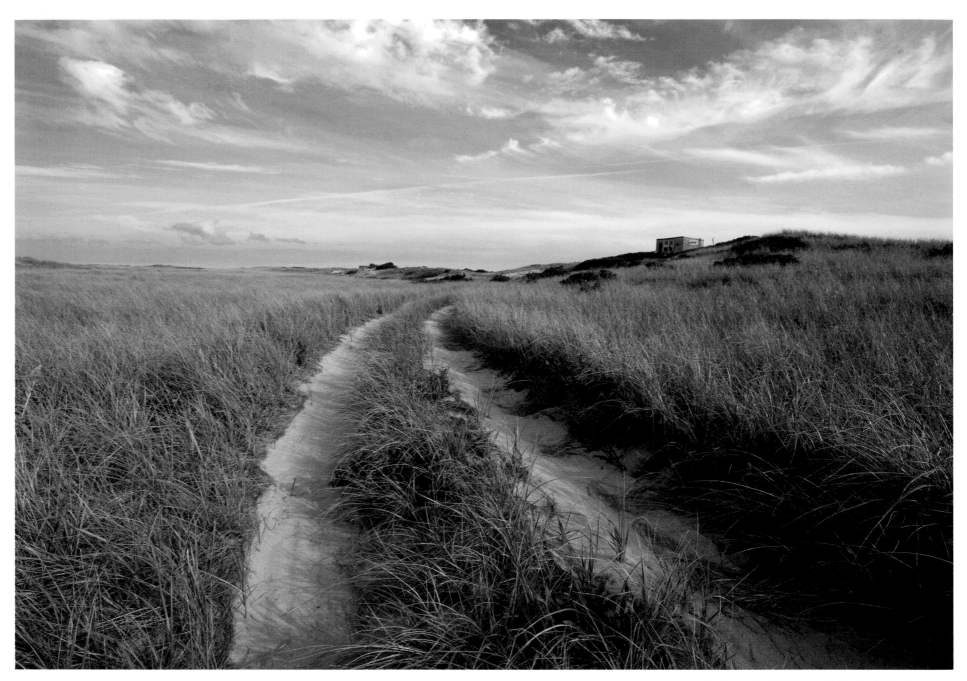

Sand road to the Margo Gelb shack, Provincetown

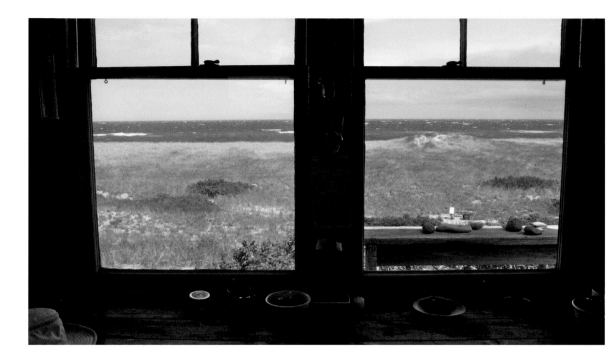

Ocean view from the
Margo Gelb shack,
Provincetown

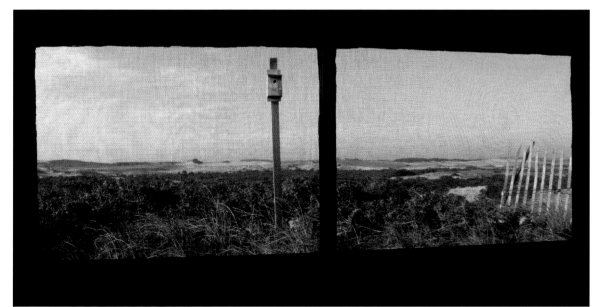

Back yard view from
the Margo Gelb shack,
Provincetown

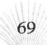

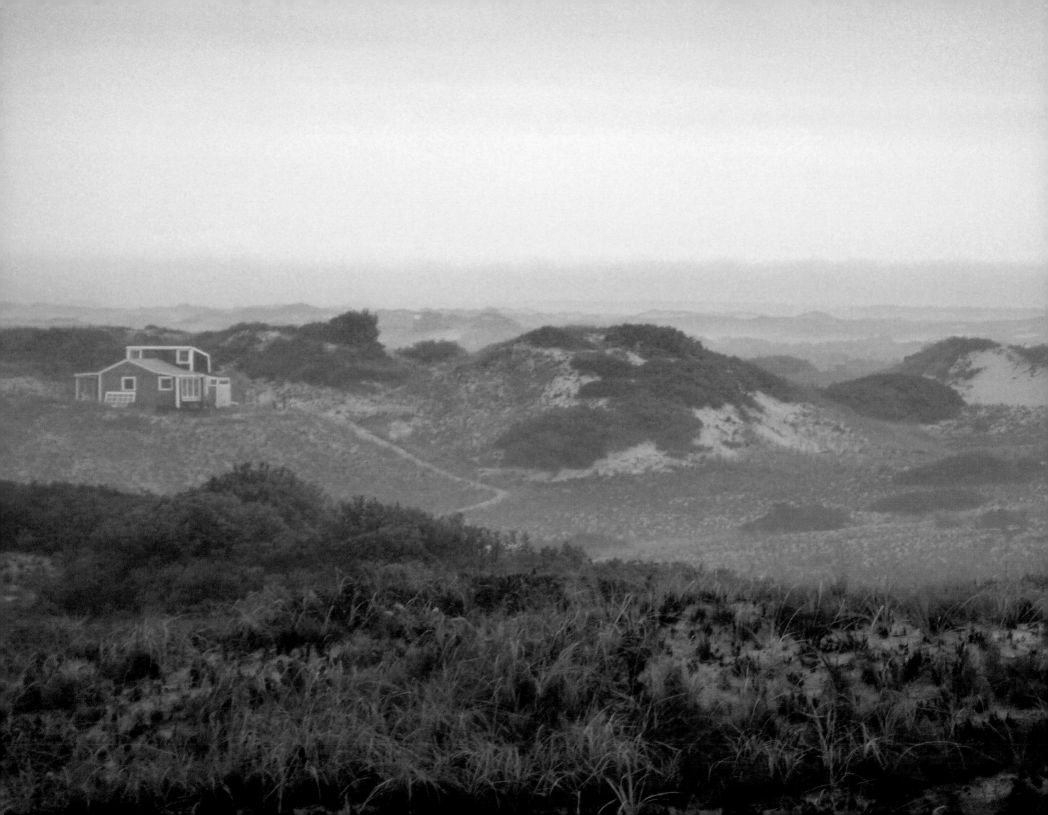

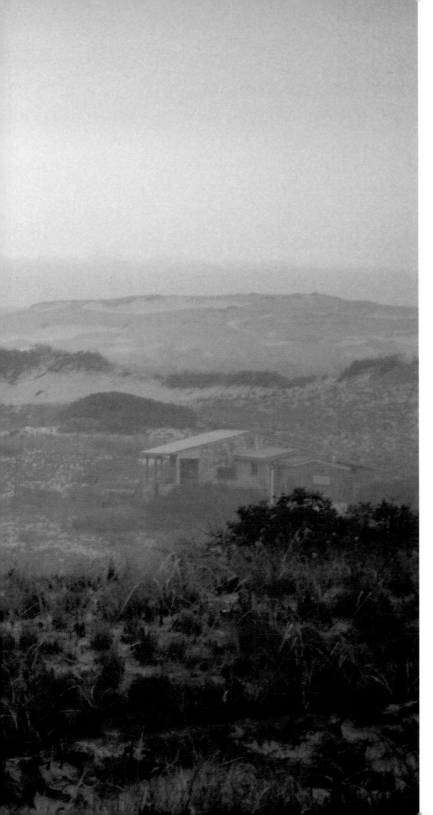

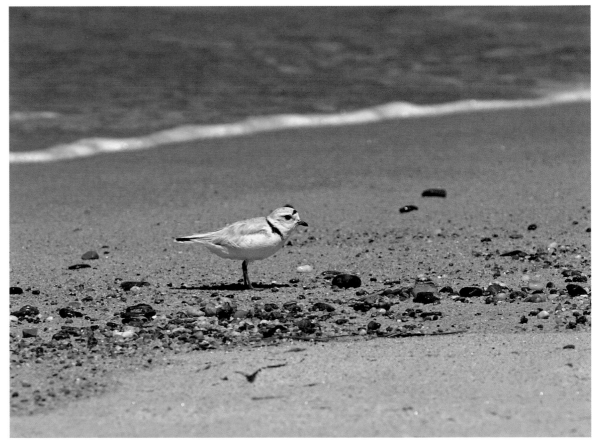

The threatened Piping Plover, Truro. The most recent surveys place the Atlantic population at less than 1800 pairs.

A foggy day in the dunes, Provincetown

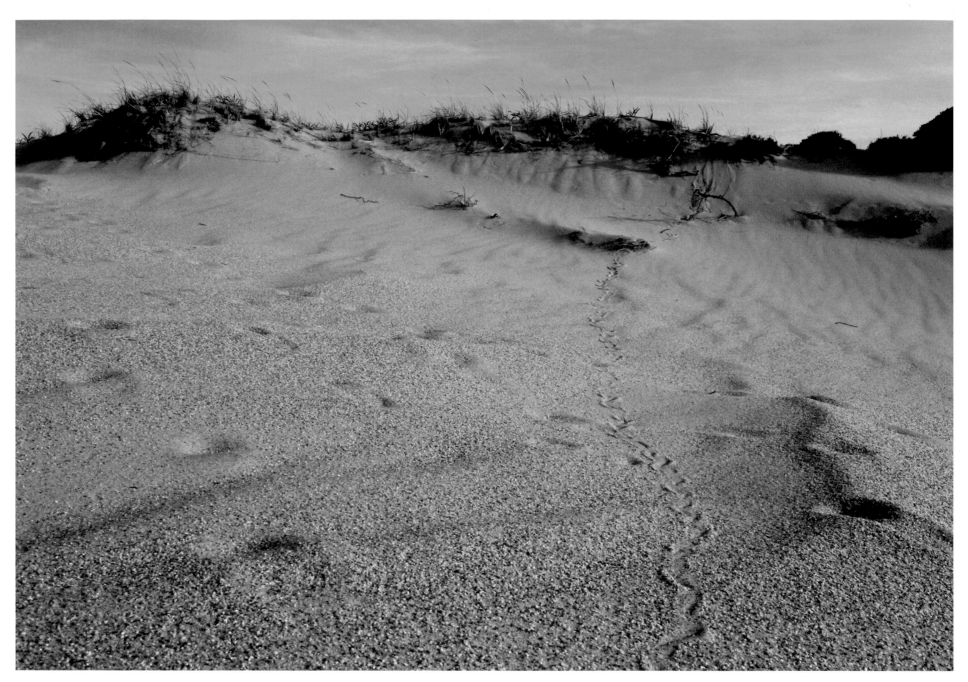

Snake trail, Provincetown

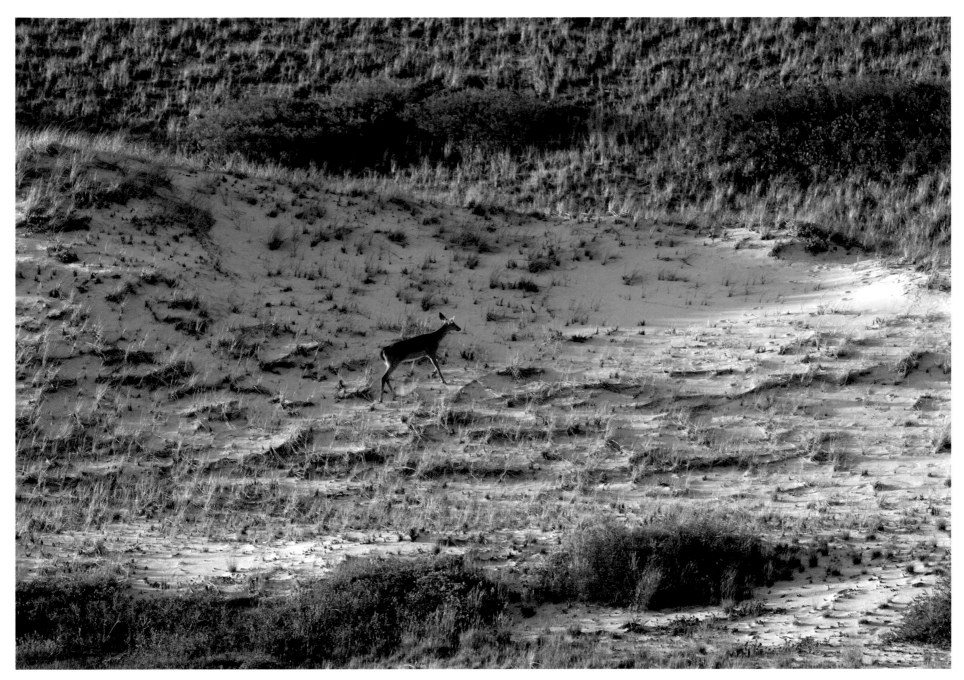

White tail deer, Provincetown. This one had been drinking fresh water near a wild cranberry bog in the dunes.

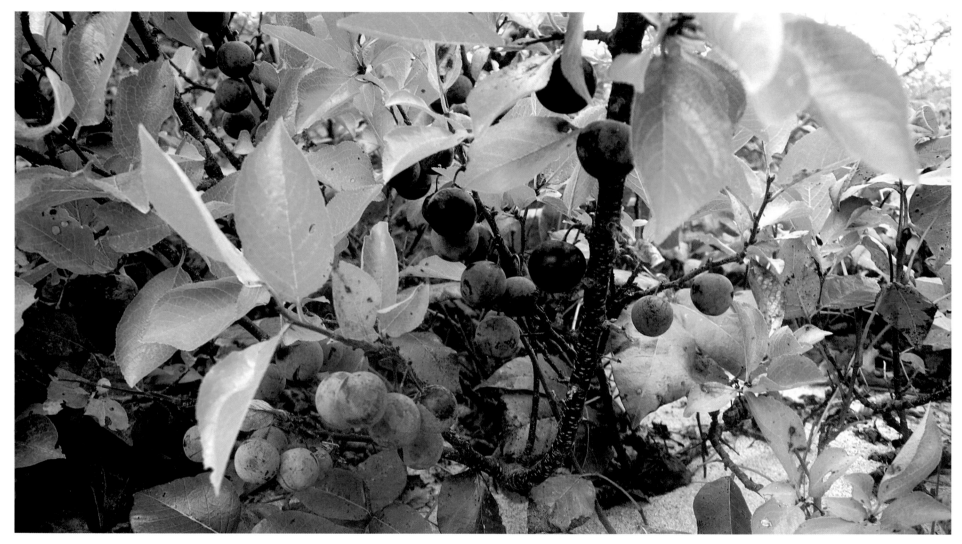

Beach plums, Provincetown

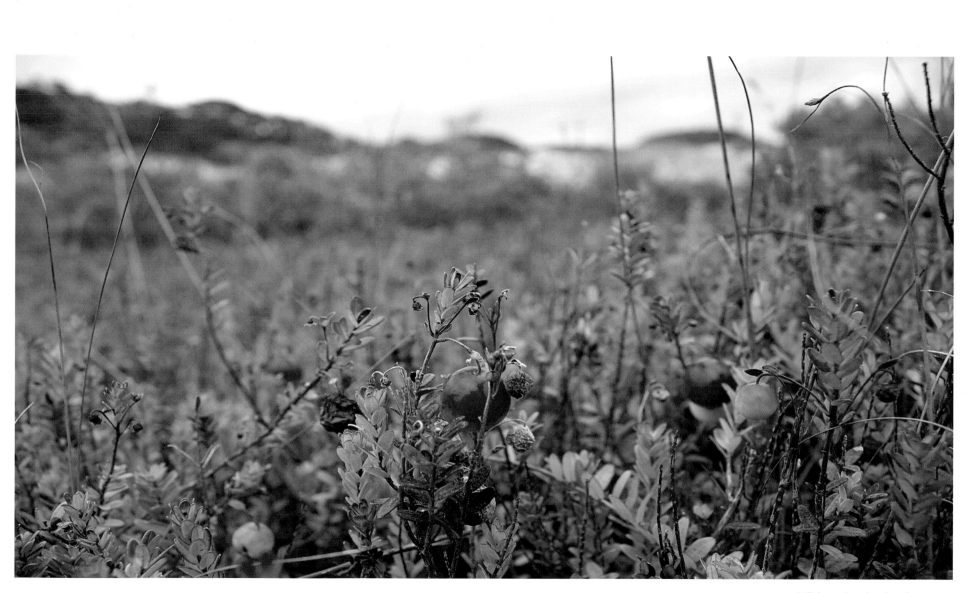

Wild cranberries, Provincetown

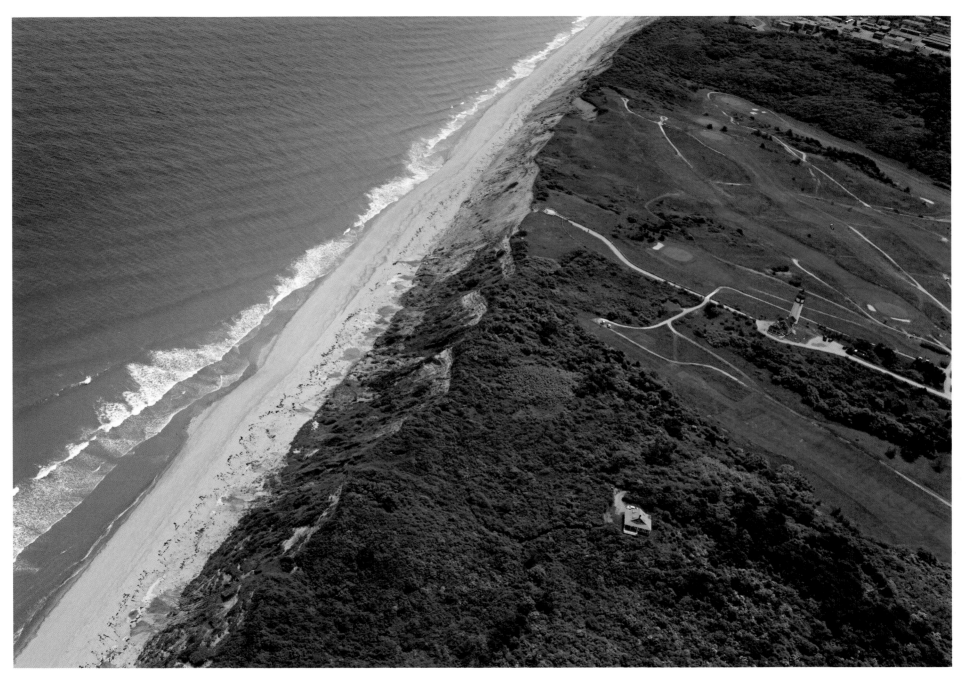

Highland Lighthouse aerial, Truro

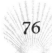
76

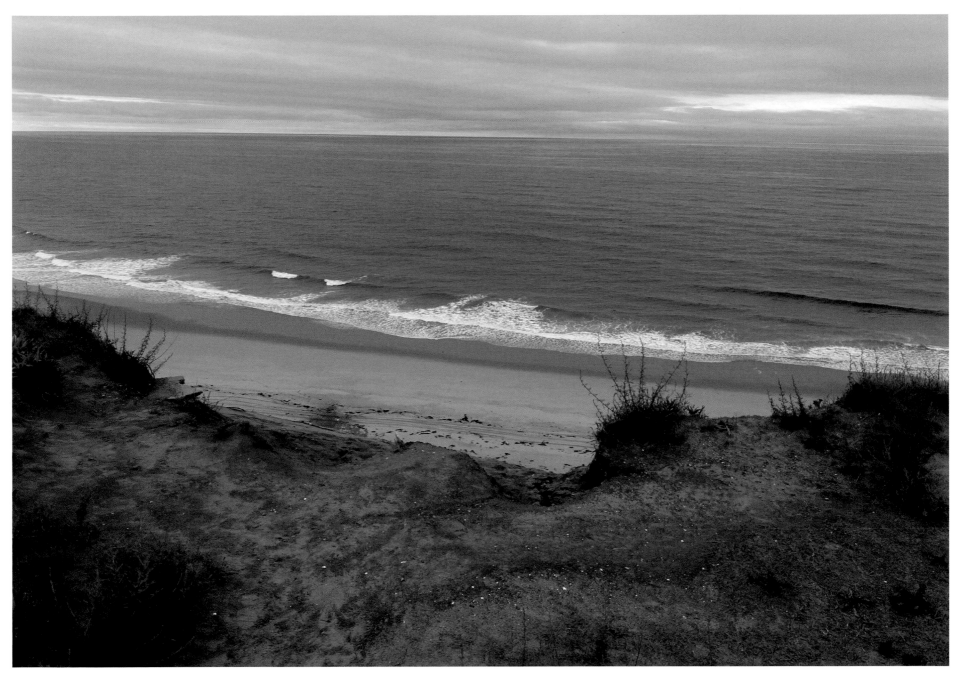

View from the Highland Lighthouse bluff, Truro

Cape Cod Highland Lighthouse (high dynamic range image) built in 1857, Truro

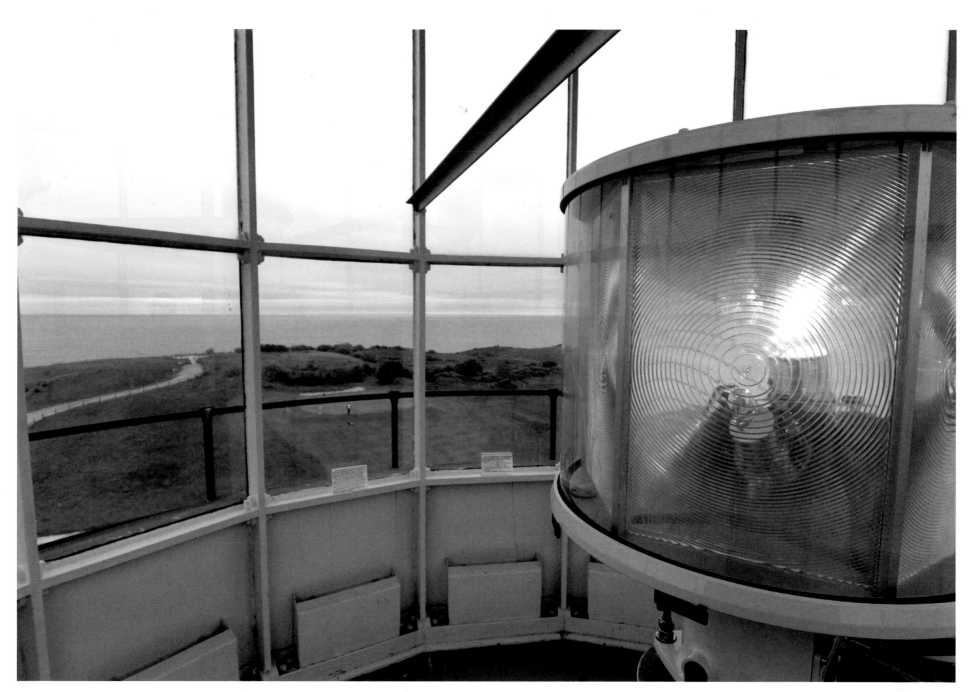

Turret of the Highland Lighthouse, Truro. The first light was fueled with whale oil, then lard, kerosene, and finally, electricity. In 1901 a "First Order" Fresnel lens greatly extended the seaward reach of the beam of light, flashing one half-second burst of light every 5 seconds. In 1932 the light was electrified. During the 1950s this Fresnel lens was replaced by a four-way beacon. In 1986 the Highland Light was automated with a 2-way beacon.

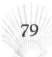

79

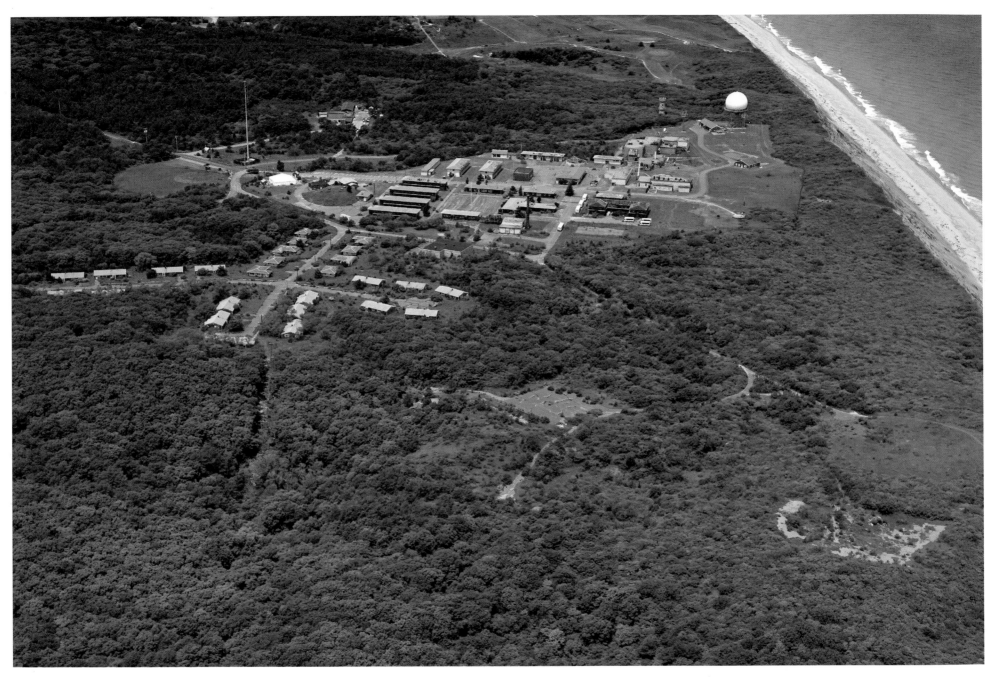

North Truro Air Force Station (1947-1994) aerial. A helipad returns to grass in the lower part of the photo. Also included here is the medieval-looking Jenny Lind Tower (top of page). Originally part of the Fitchburg Railway depot in Boston, it was moved here in 1927 by Henry Aldrich, a fan of the famous Swedish opera singer Jenny Lind, who is rumored to have sung from the tower.

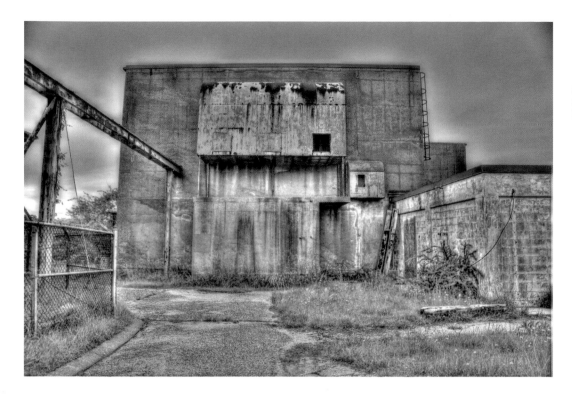

Abandoned building (high
dynamic range image) at the
North Truro Air Force Station

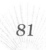

Hallway of an abandoned building
(high dynamic range image) at the
North Truro Air Force Station

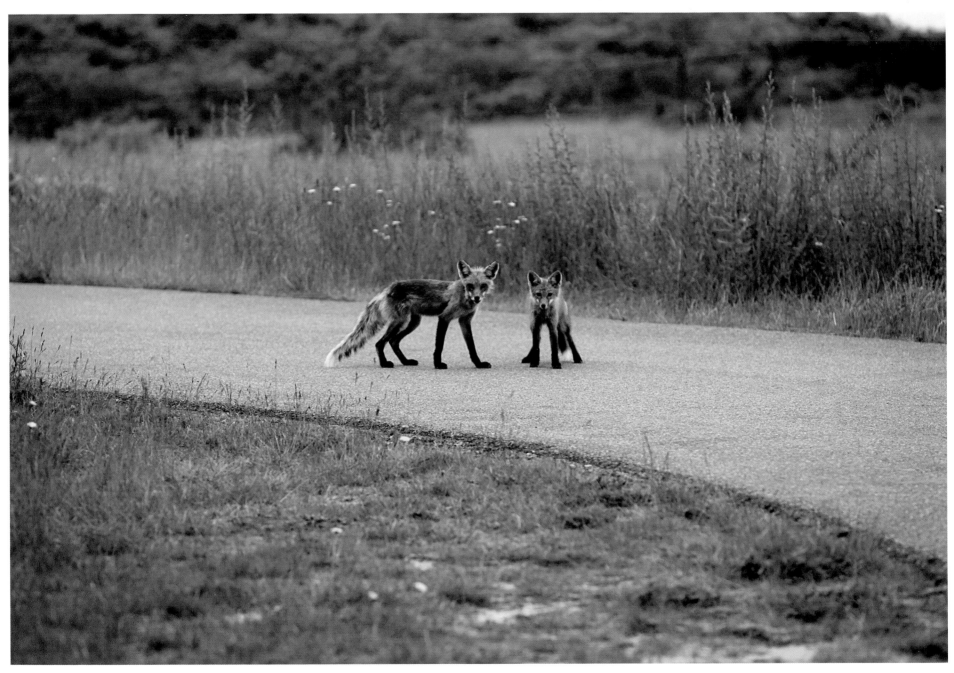

Fox kits, North Truro Air Force Station

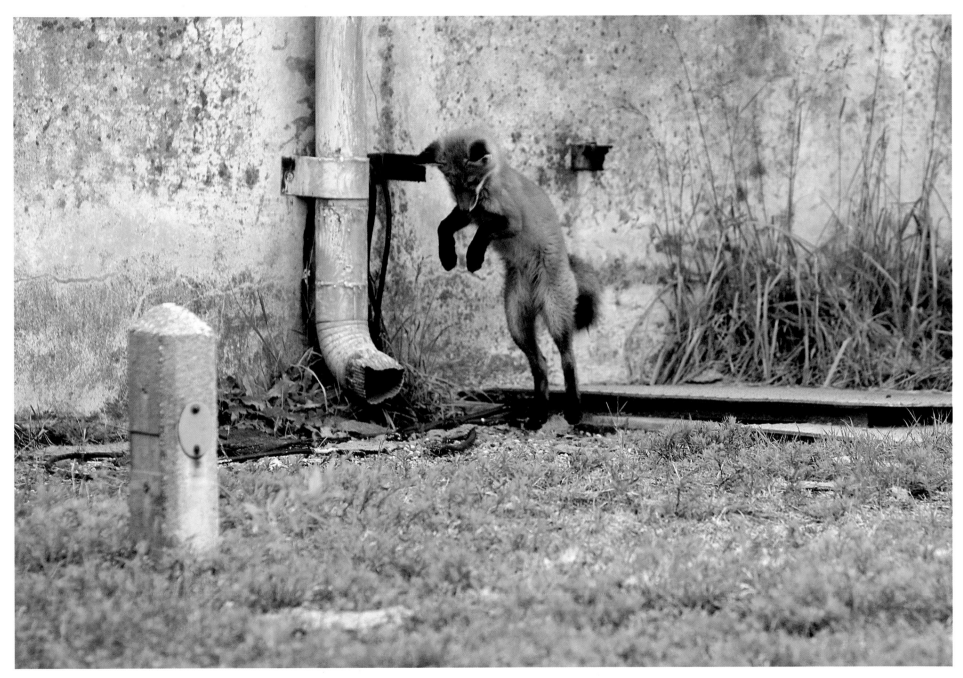

A fox pounces on a mouse at the North Truro Air Force Station.

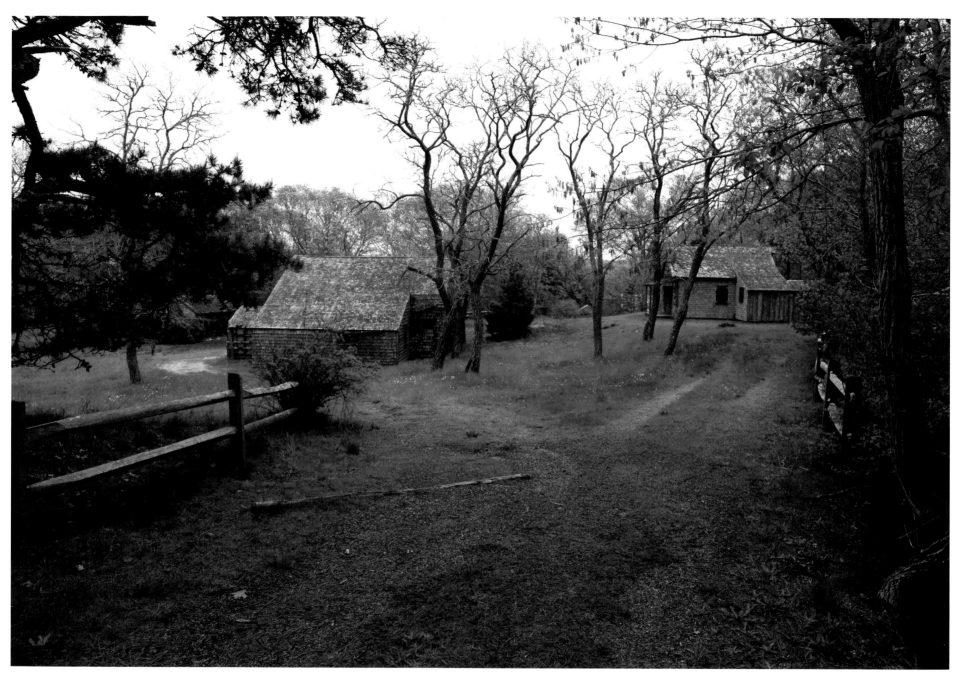

The Atwood-Higgins House was built on Bound Brook Island, Wellfleet in 1730 and may be the oldest house on the Lower Cape.

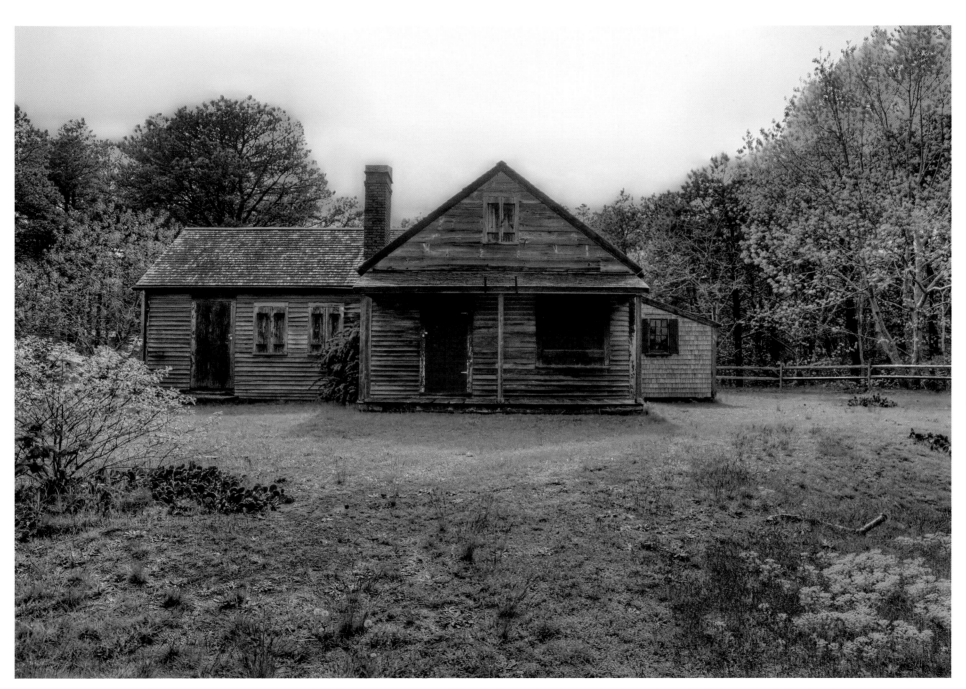

Upon inheriting the Atwood-Higgins property George Higgins built this country store/post office (1948), modeled after one he often visited with relatives in North Pomfret, Vermont.

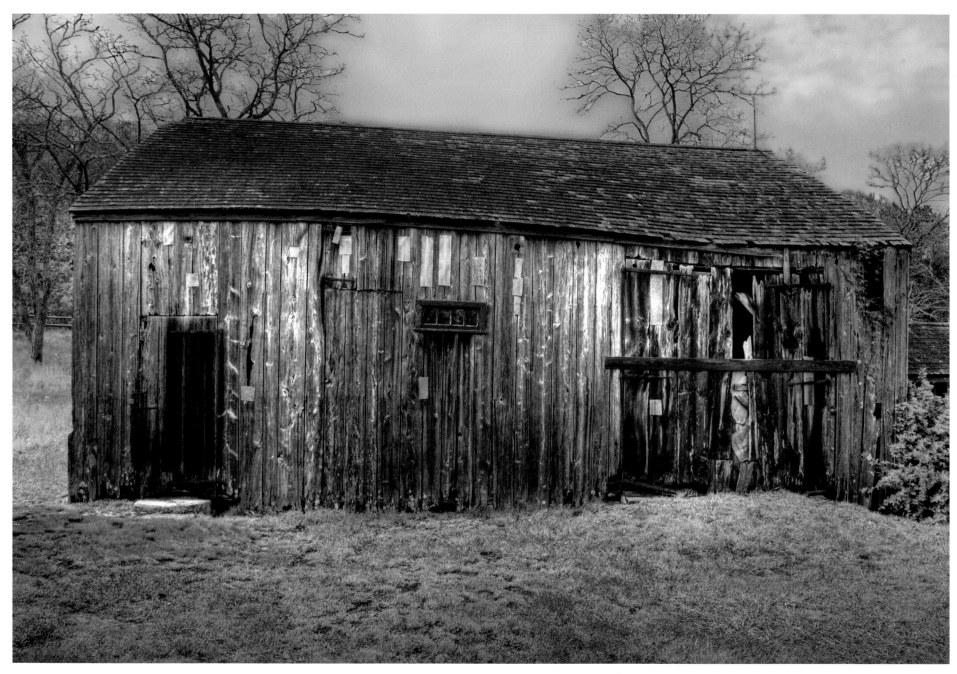

Atwood-Higgins House Barn (high dynamic range image), Wellfleet

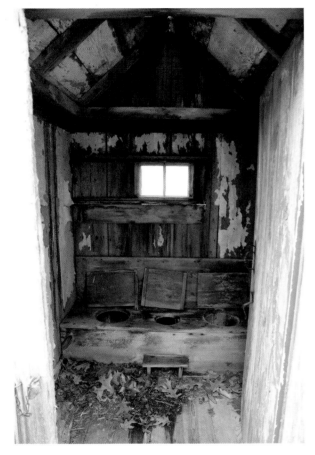

Atwood-Higgins House outhouse, Wellfleet

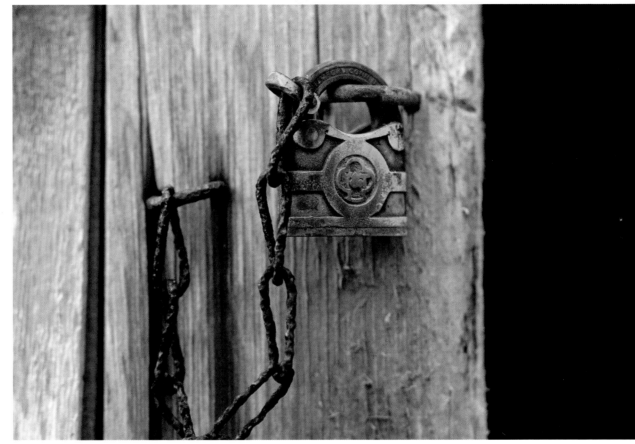

Atwood-Higgins House outhouse lock, Wellfleet

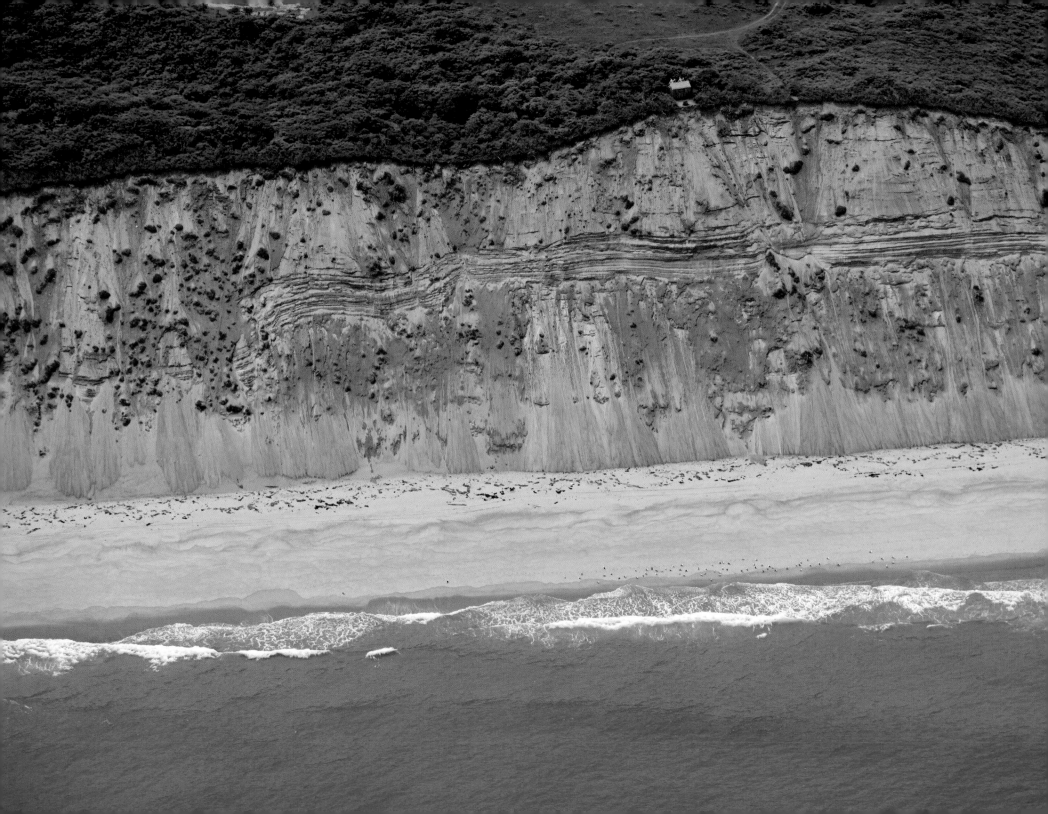

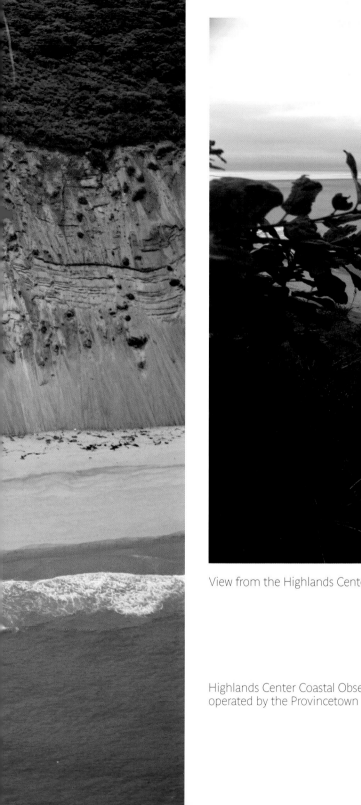

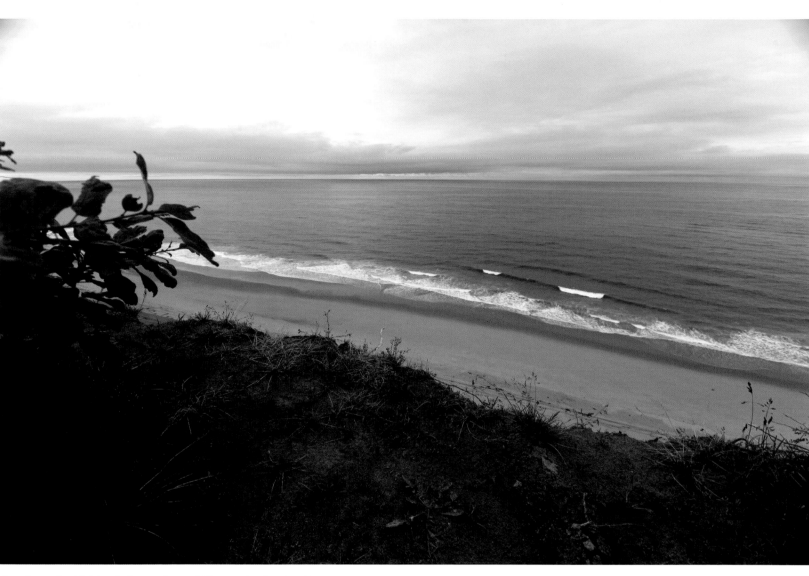

View from the Highlands Center Coastal Observation Station, Truro

Highlands Center Coastal Observation Station (Wave Lab),
operated by the Provincetown Center for Coastal Studies, Truro

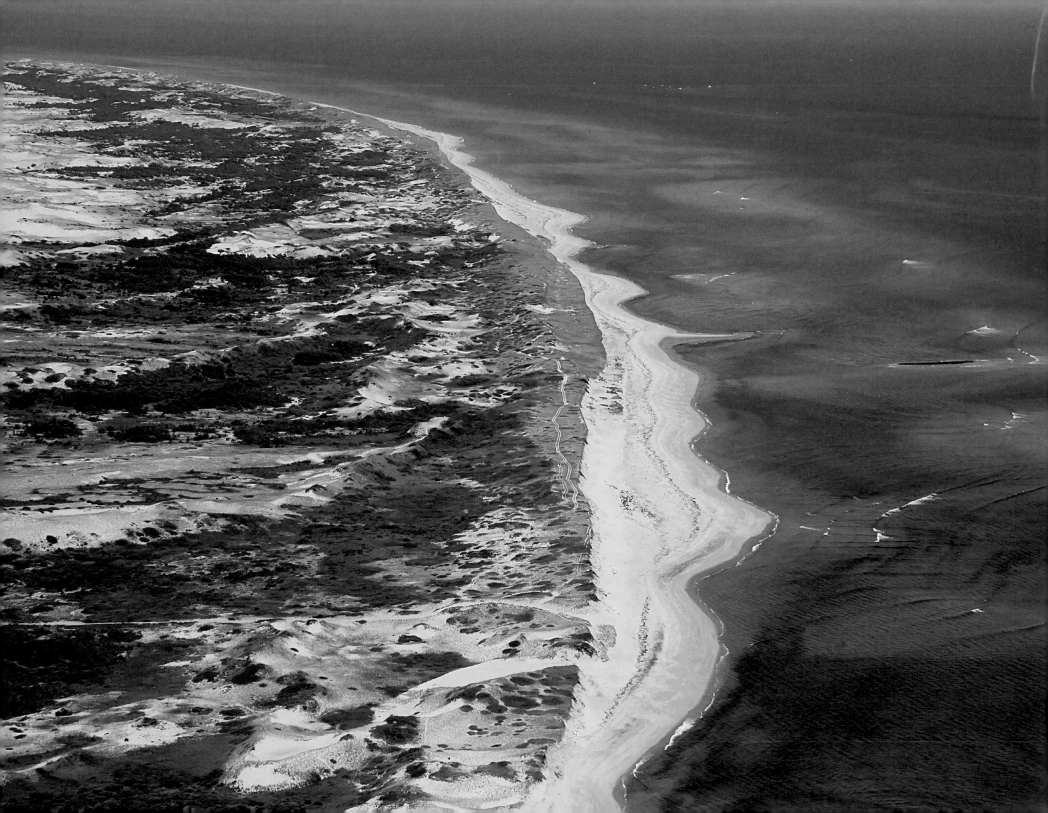

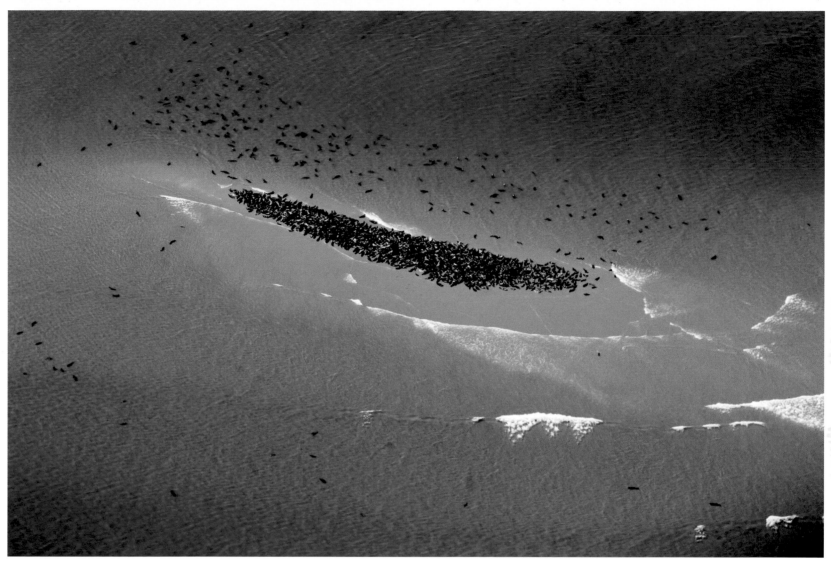

Closeup of seals on a sandspit off Truro

Seals on a sandspit off Truro

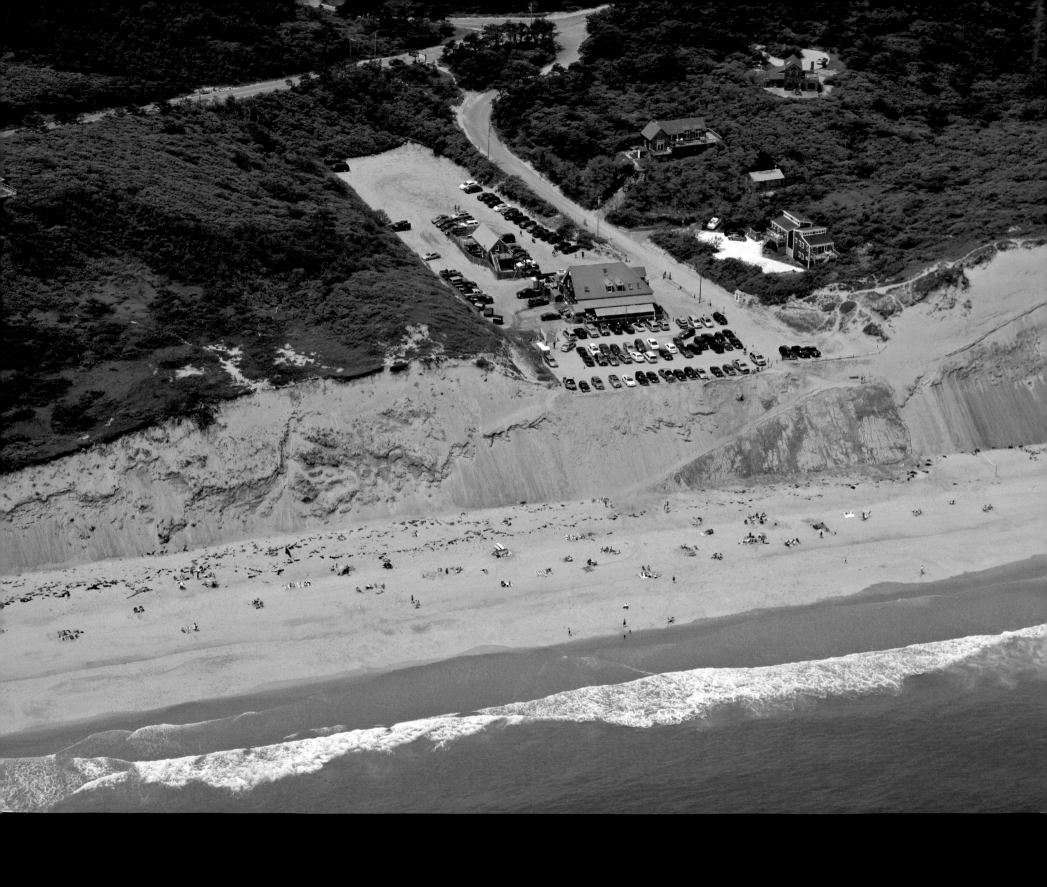

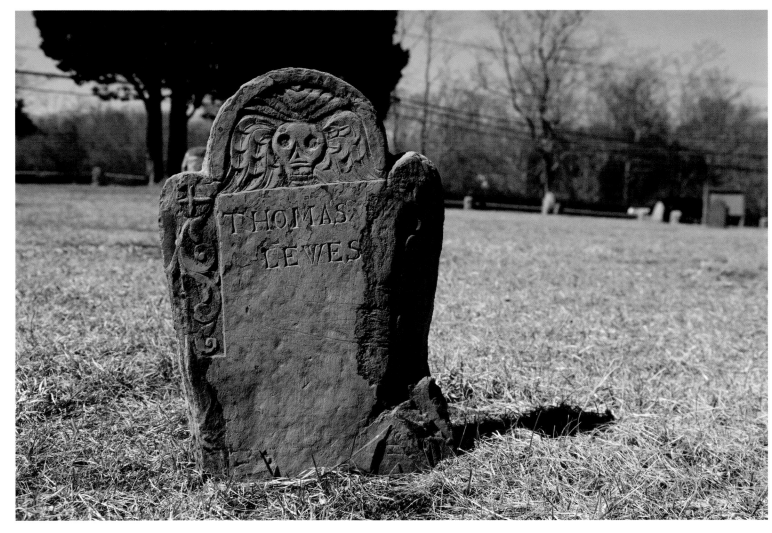

Simple grave in the Old Cove Burying Ground, Orleans. The graveyard is also home to several passengers of the Mayflower.

Aerial of the Cahoon Hollow U.S. Life Saving Station, originally built in 1853 and re-built in 1897 after being destroyed by fire. This is the only station of the nine original stations that remains at its original site. It is now the Wellfleet Beachcomber.

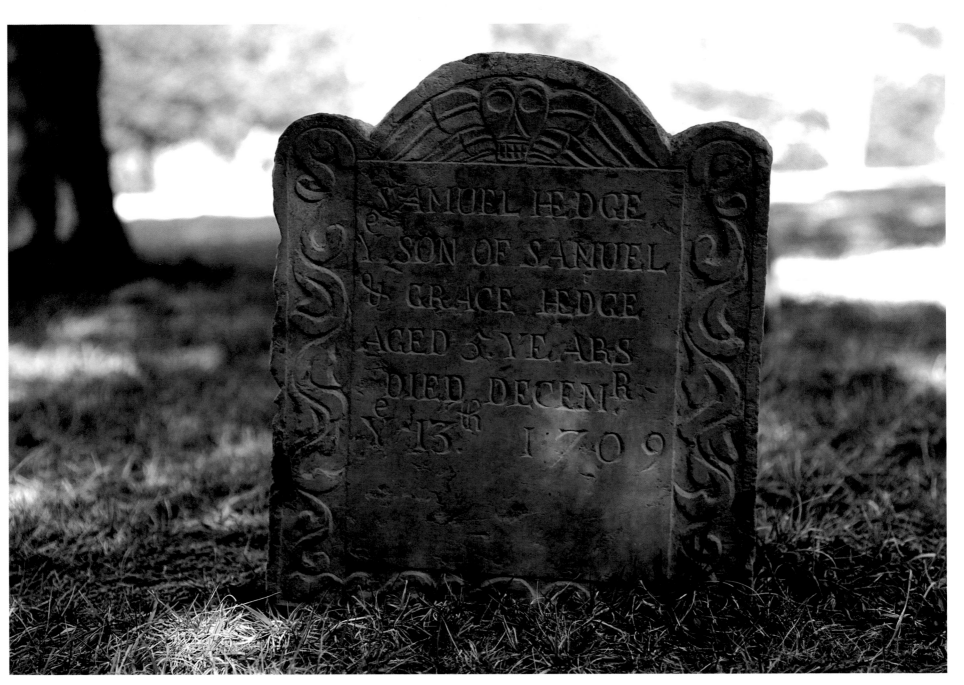

The sadness of this grave at the Old Cove Burying Ground, Orleans, transcends the centuries.

Here's a little known historical site in the Cape Cod National Seashore. This fire road is actually the remnants of a stretch of the Old King's Highway, which ran past the village at Fresh Brook, Wellfleet. These woods once harbored a village, settled in 1730. The village was occupied by perhaps a dozen families at its peak. It was a quiet place where mackerel fishermen came home down the Fresh Brook from their labors in small boats in Cape Cod Bay. The houses were small and usually included enough land for a small garden plot. There was a store and Aunt Lydia Taylor's tavern, where travelers using the stage along the Kings Highway might stop for refreshment. Children attended a one-room school nearby. Cellar holes from these 300 year-old structures can still be seen here, dotted throughout the oddly hilly features in the pine forest.

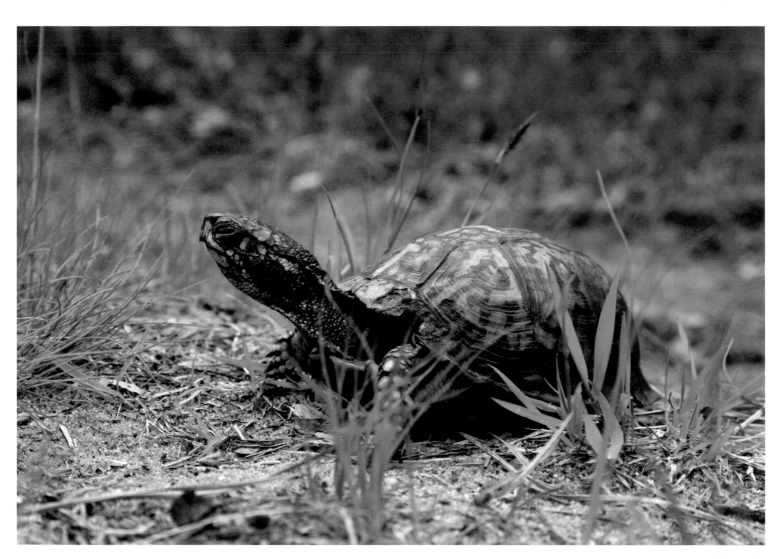

Box turtle

Late day sunlight bathes a snake-like
dune in the Provincelands.

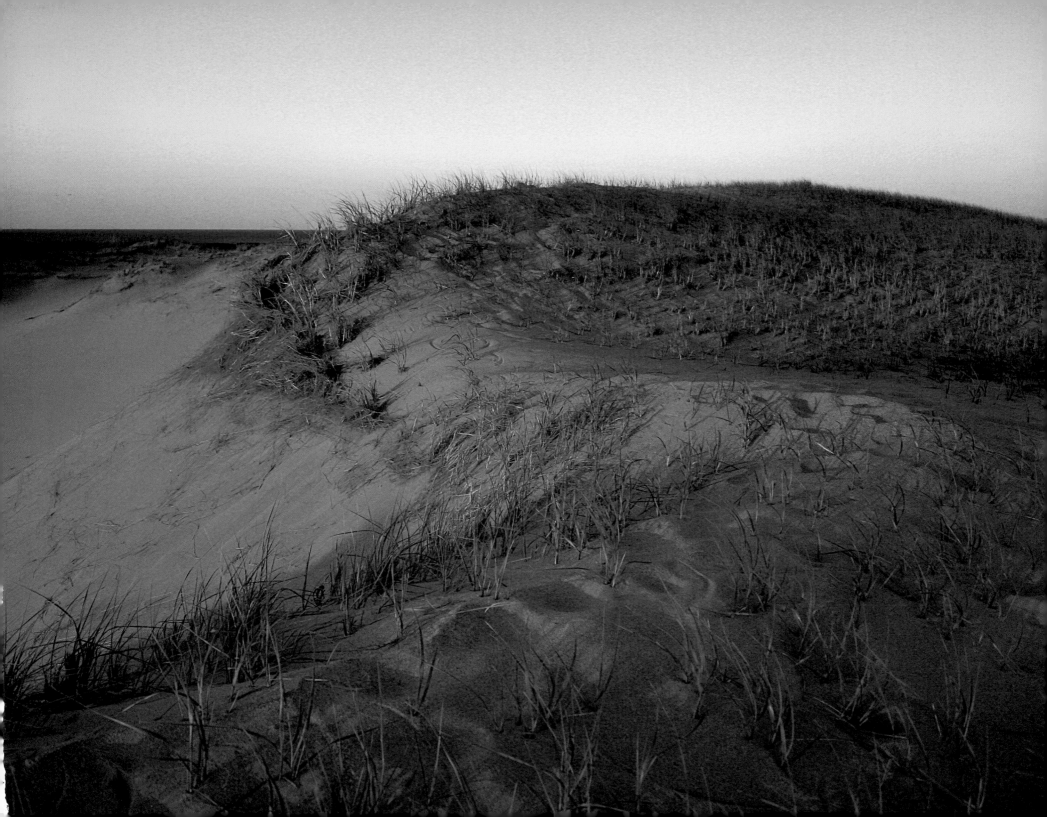

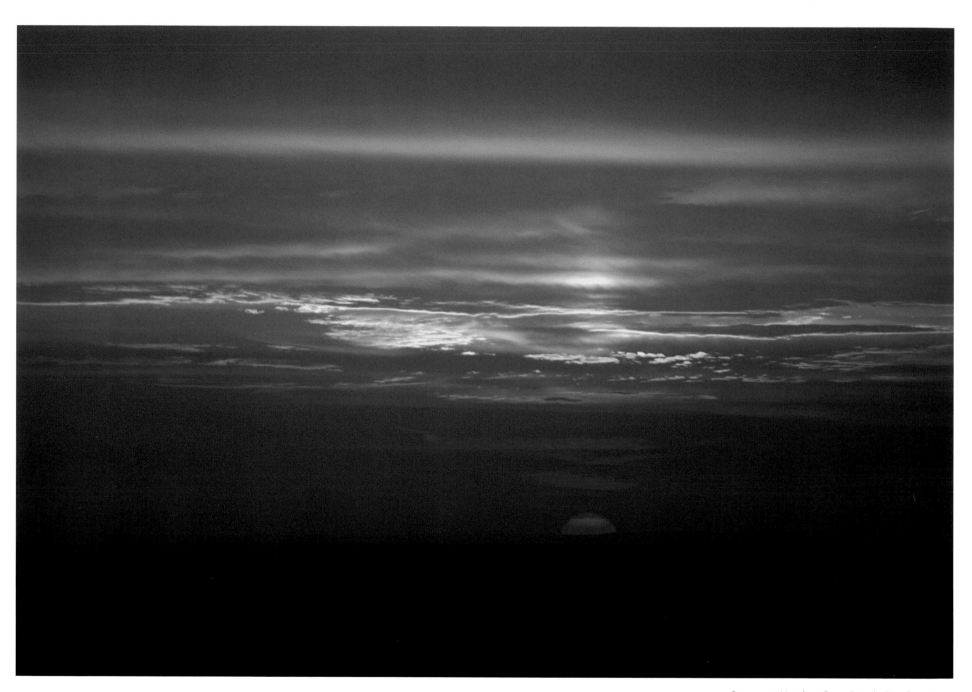

Sunset at Herring Cove Beach, Provincetown

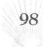

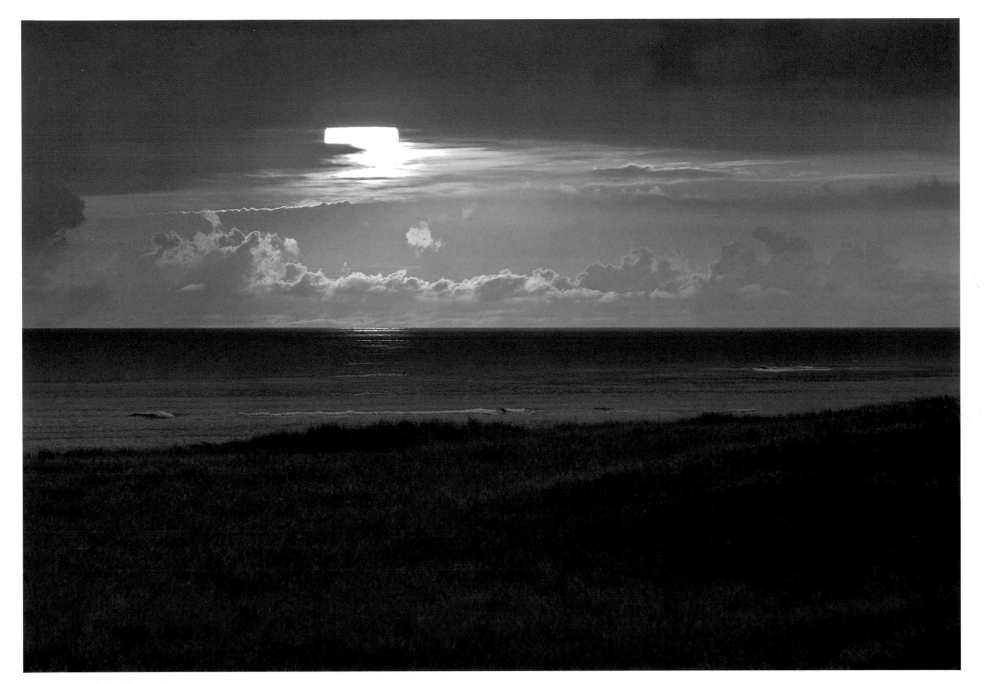

Sunrise at Peaked Hill Bars, Truro

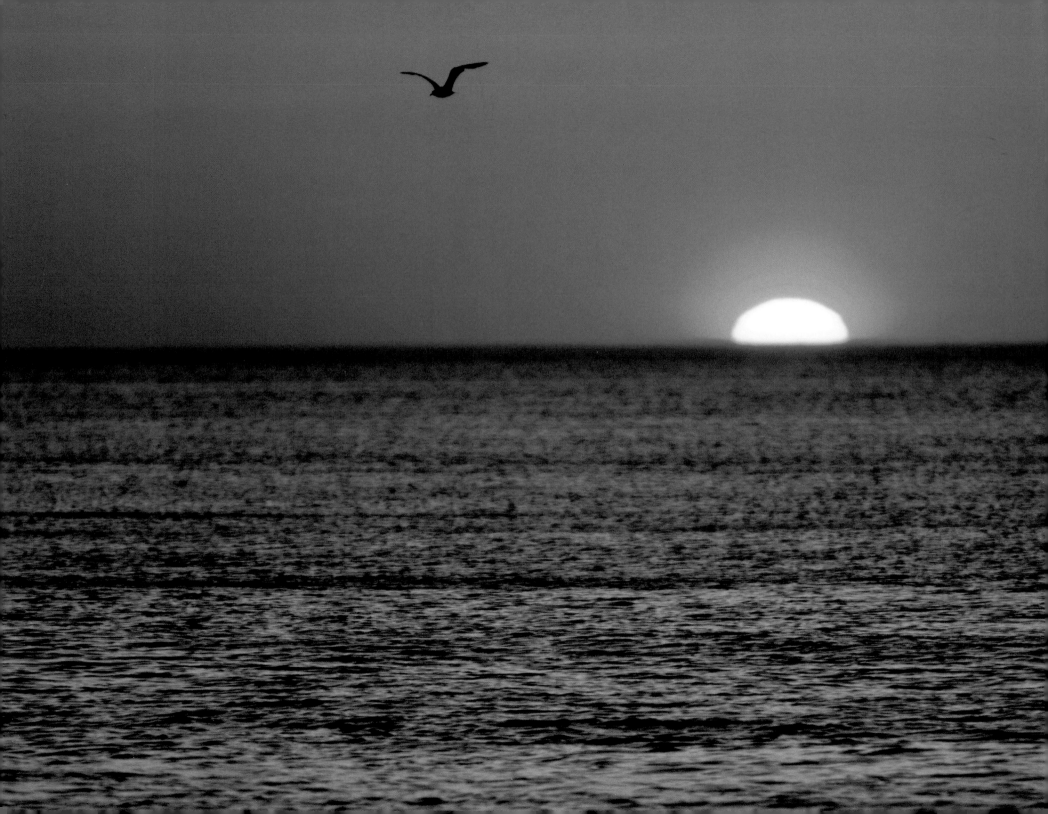

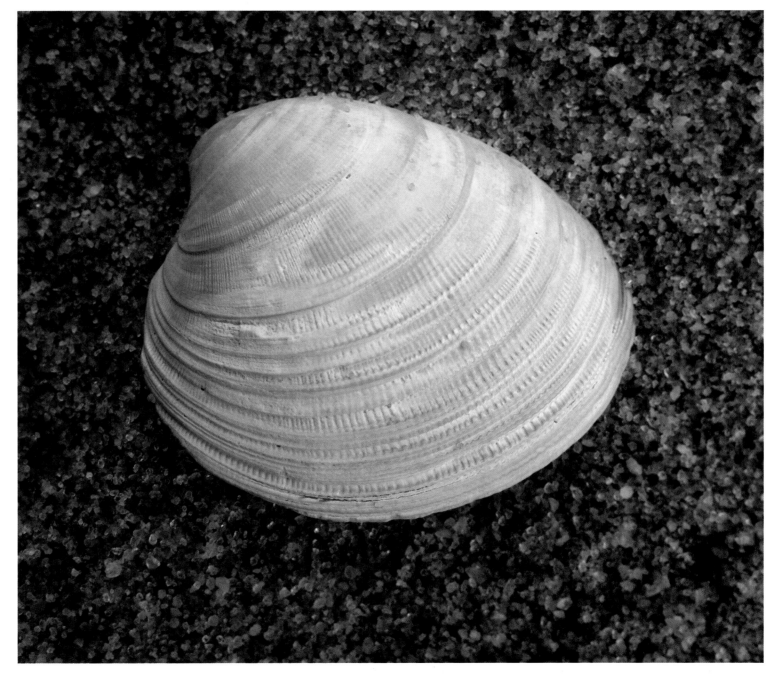

Quahog, Chatham

Seagull off Race Point, Provincetown

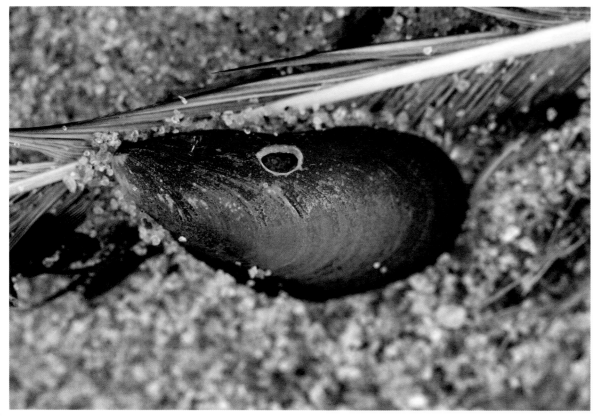

Blue mussel, Chatham

Fish bones at Peaked Hill Bars, Truro

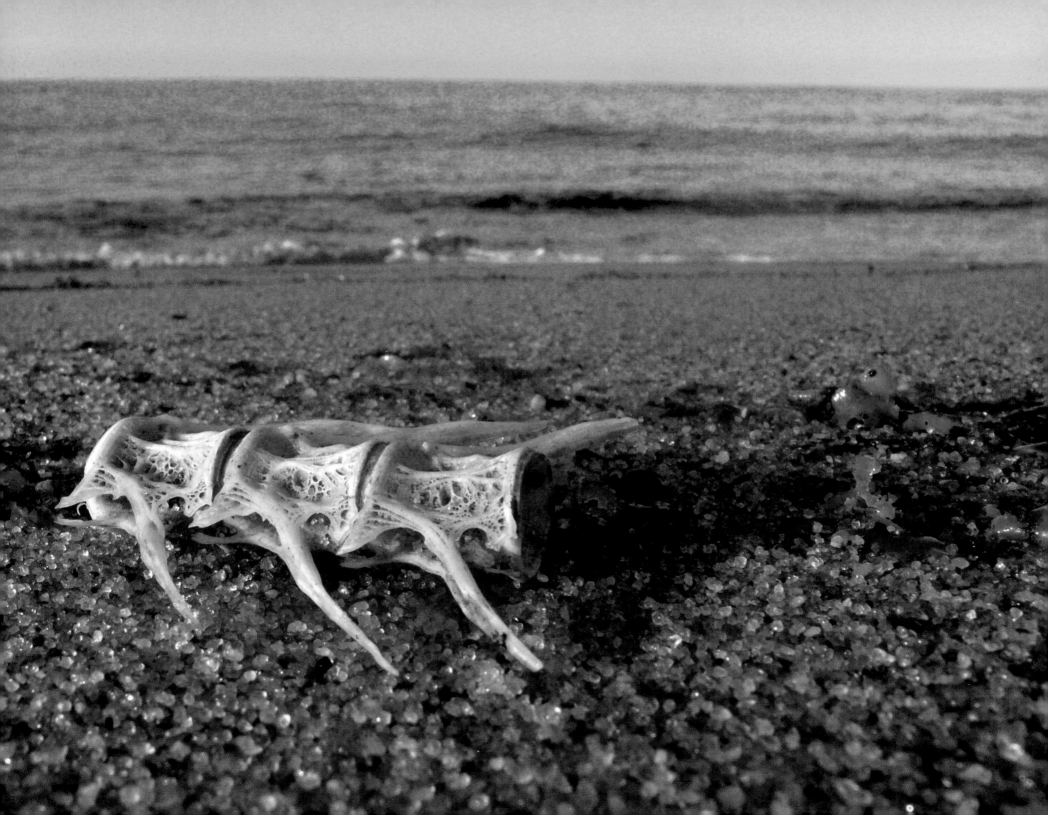

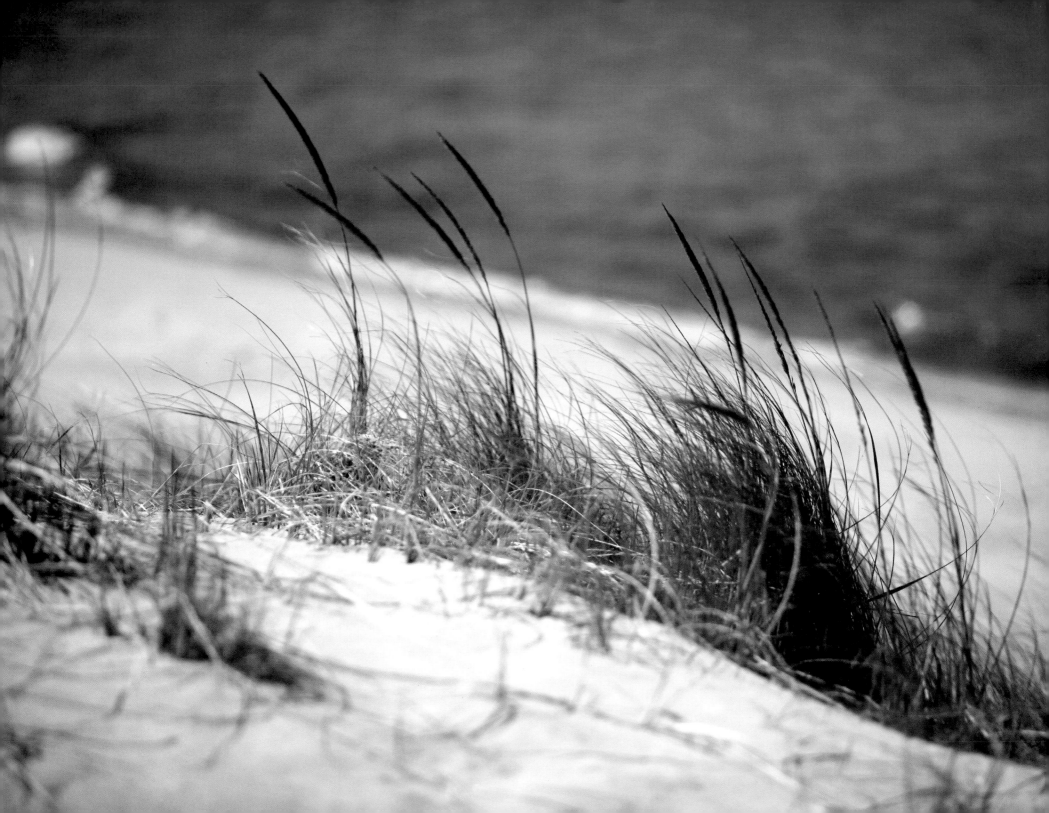

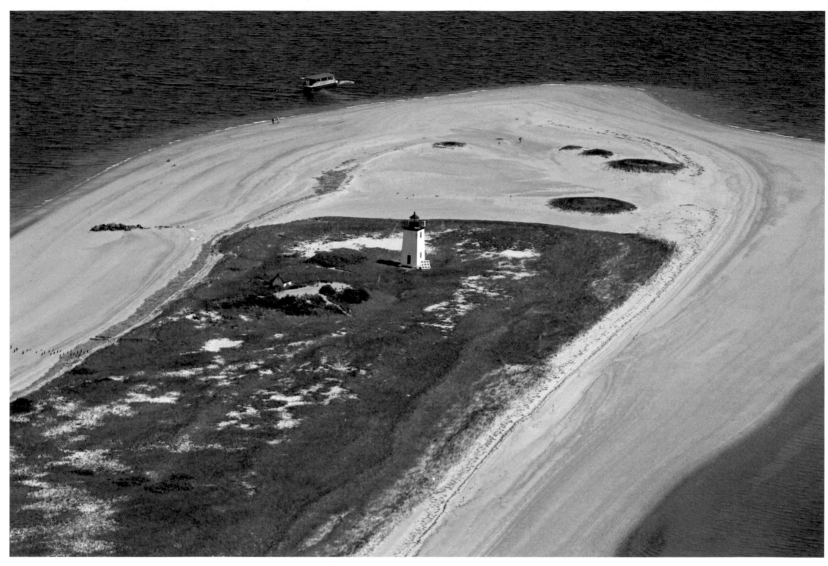

Long Point Lighthouse, Provincetown. Established in 1826, the current lighthouse tower was built in 1875. It still emits a fog horn blast every 15 seconds during times of bad visibility.

Beach grass, Orleans

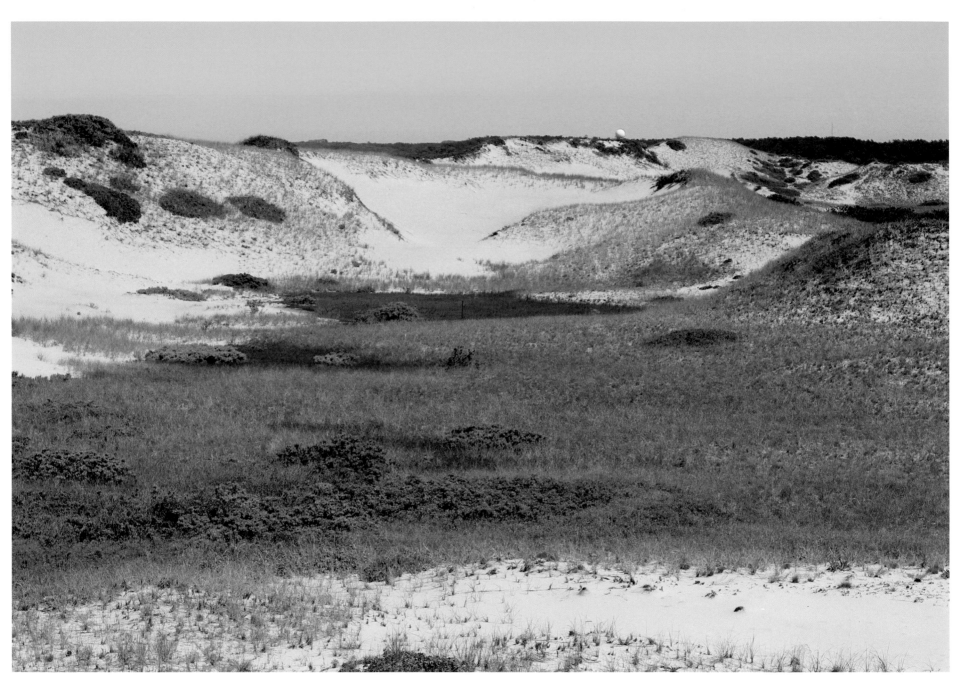

Wild cranberry bog, Provincetown

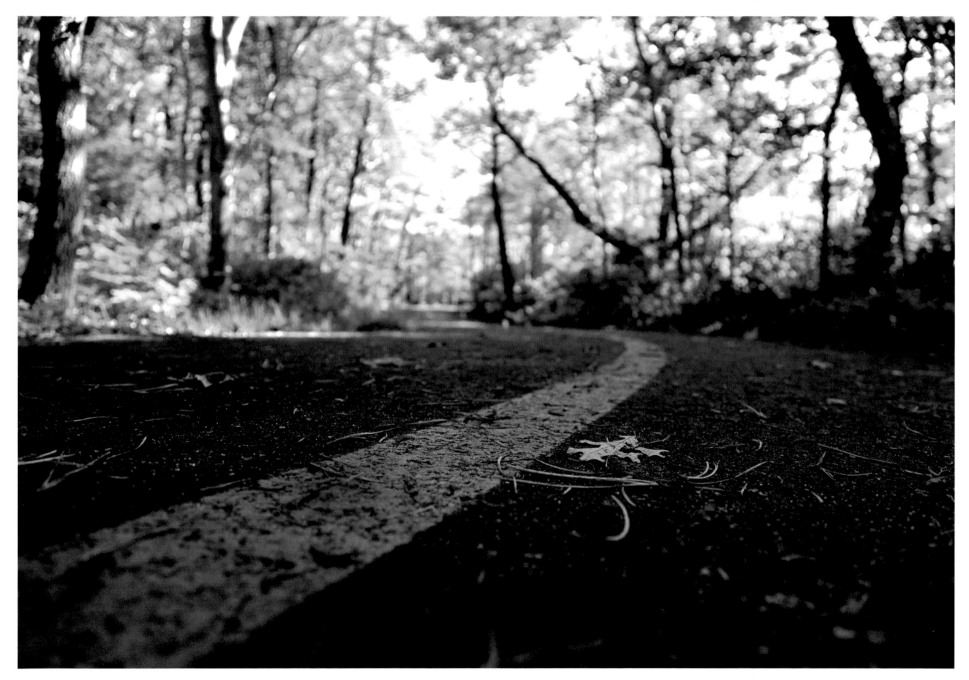

The beech forest trail at Race Point, Provincetown

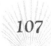

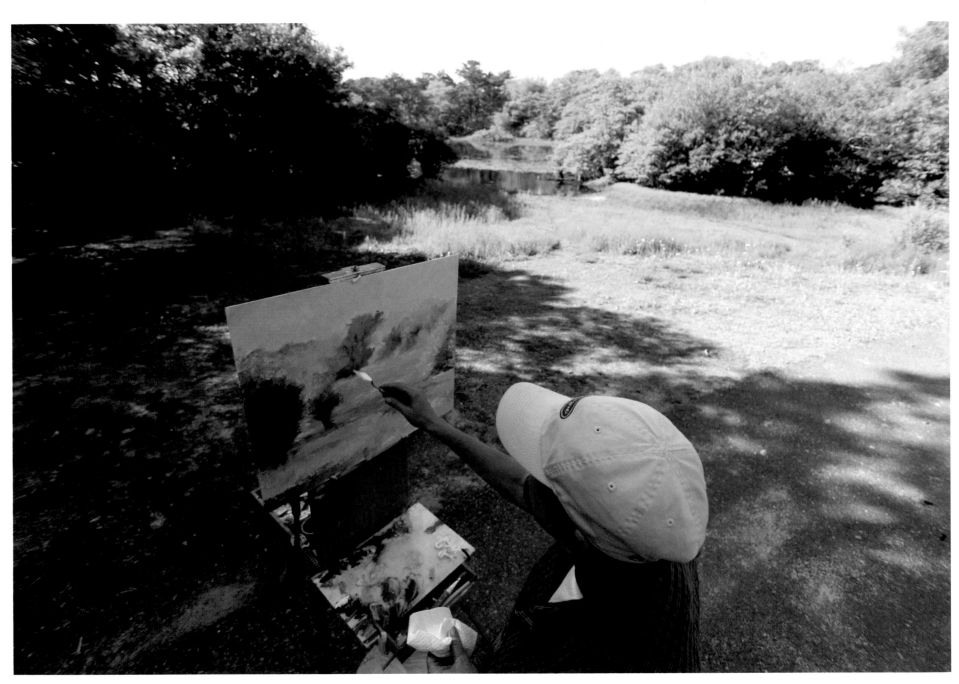

A painter renders a scene at Blackwater Pond in the beech forest trail, Provincetown.

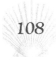

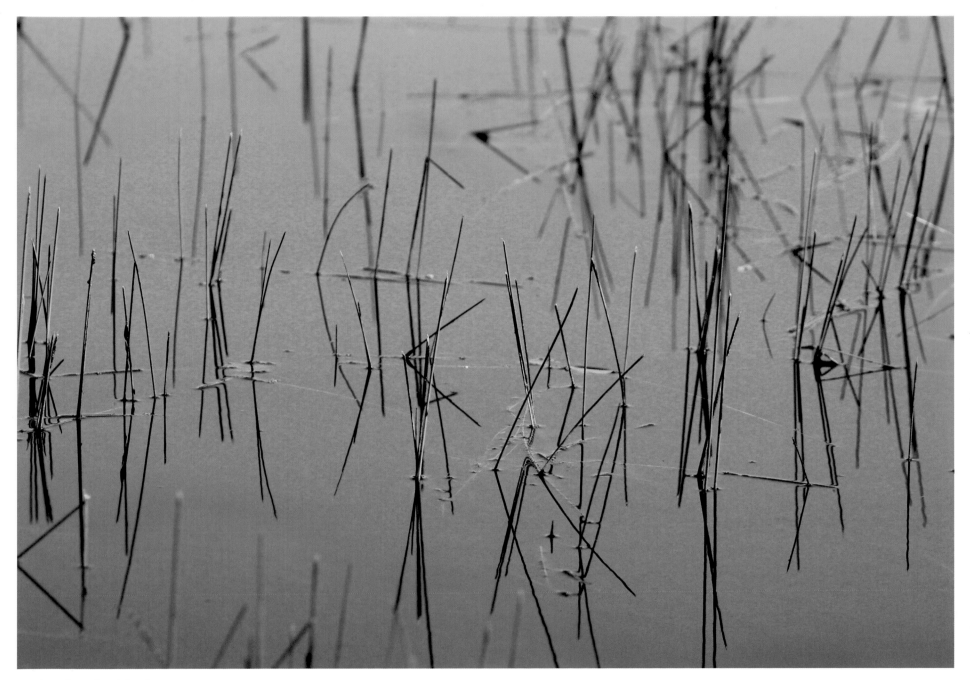

Reeds at Great Pond, Provincetown

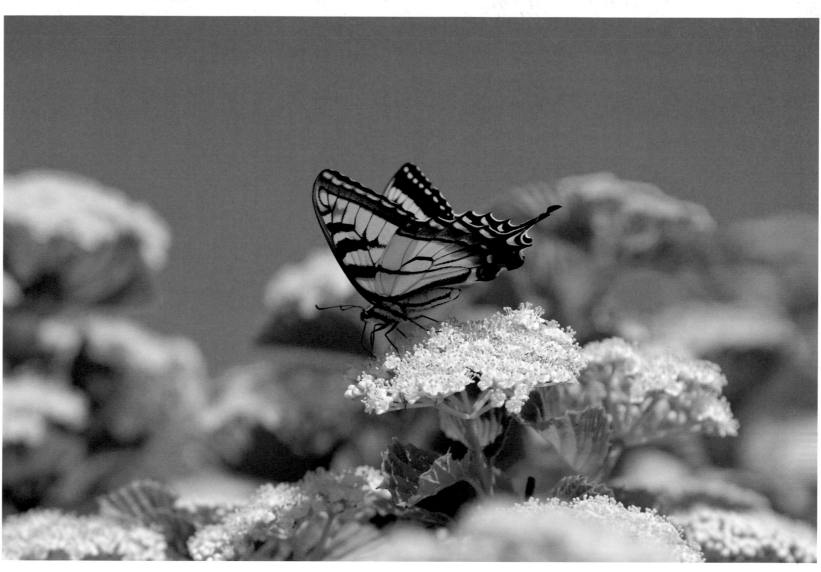

Butterfly in the Provincelands.

Sunset at the Euphoria
dune shack, Provincetown.

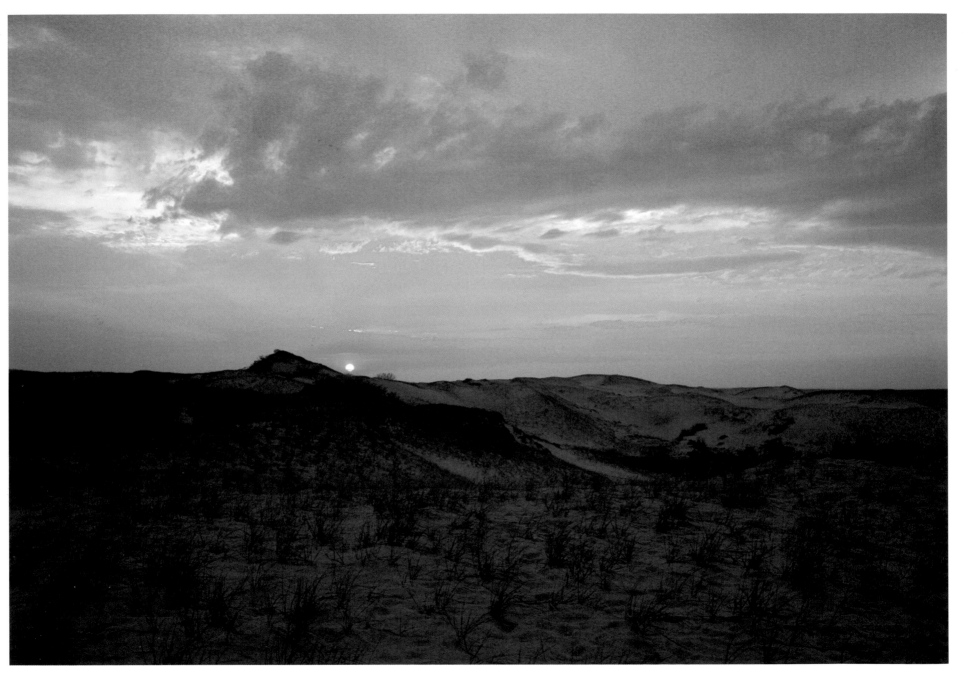

The last rays of the day touch the highest parabolic dune in the Provincelands.

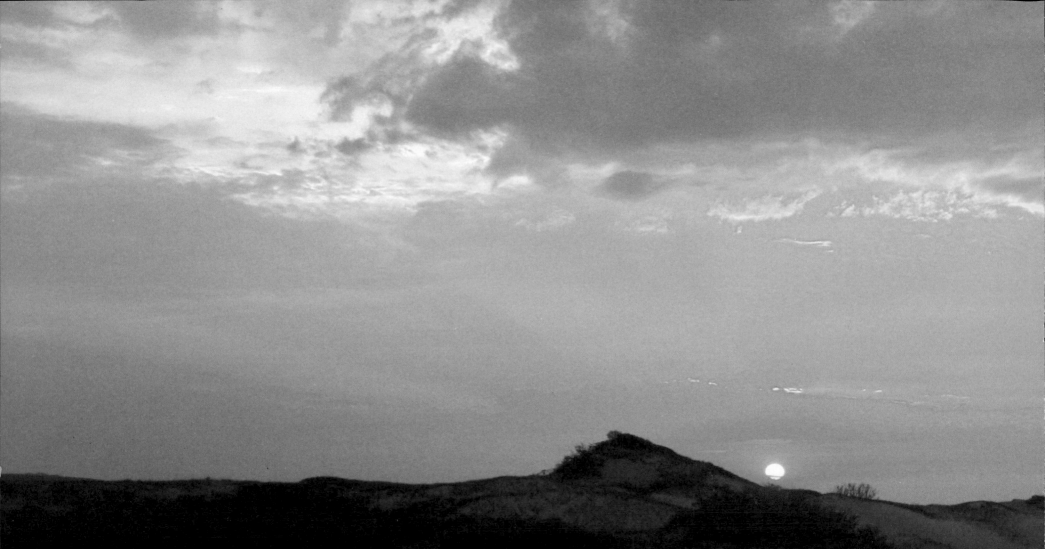